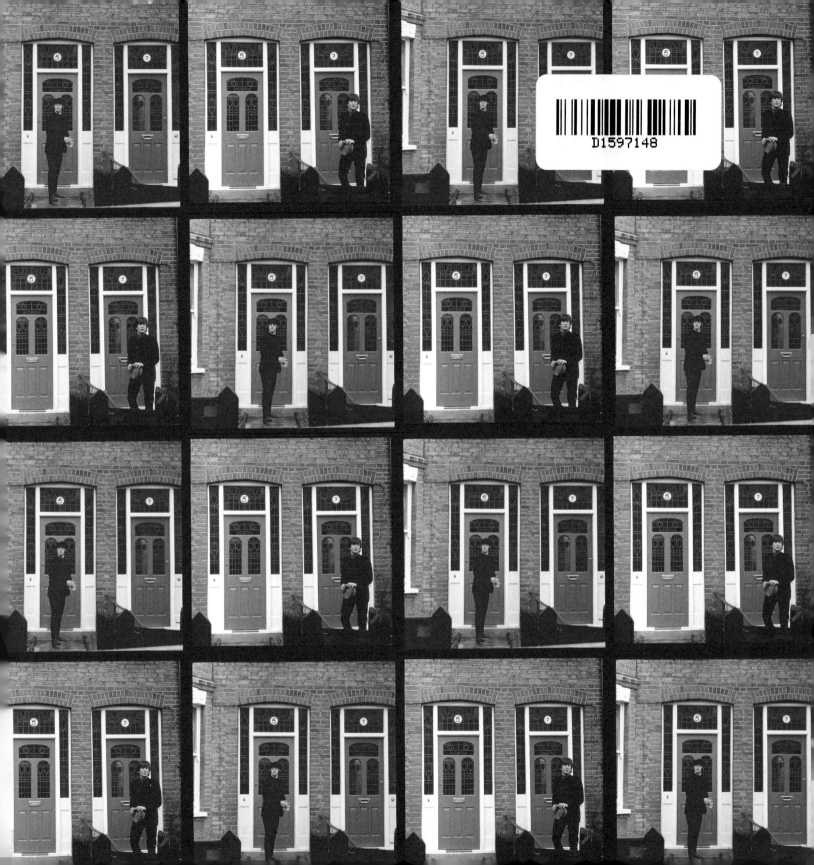

THE BEATLES

PHOTOGRAPHS FROM THE SET OF *HELP!*

THE BEATLES
PHOTOGRAPHS FROM THE SET OF *HELP!*

EMILIO LARI

Introduction
RICHARD LESTER

Text
ALASTAIR GORDON

RIZZOLI
NEW YORK

New York · Paris · London · Milan

In collaboration with Gordon de Vries Studio

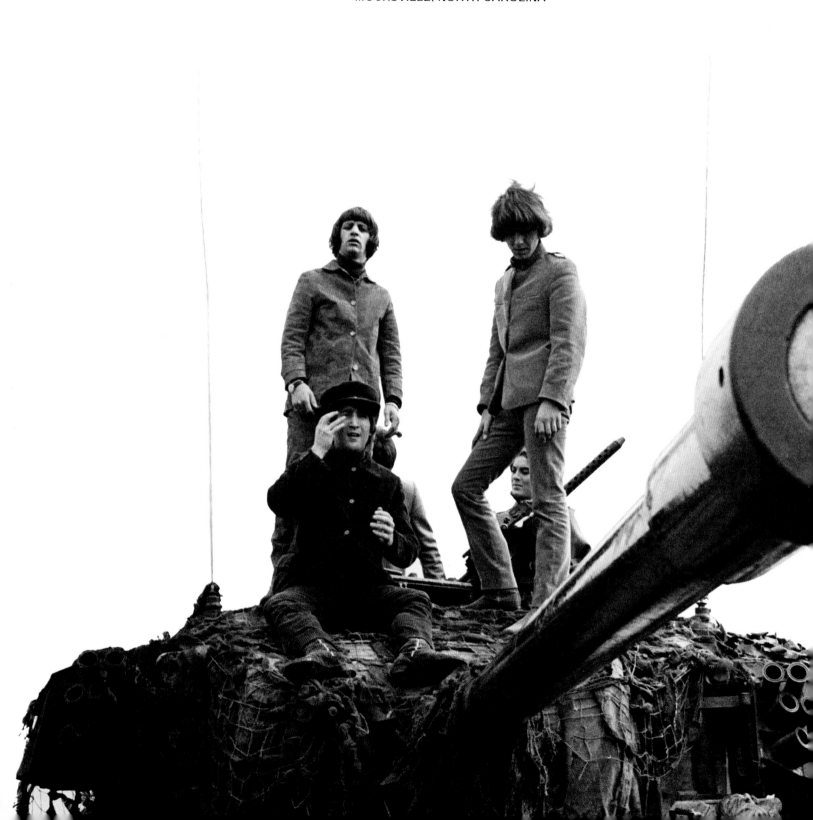

CONTENTS

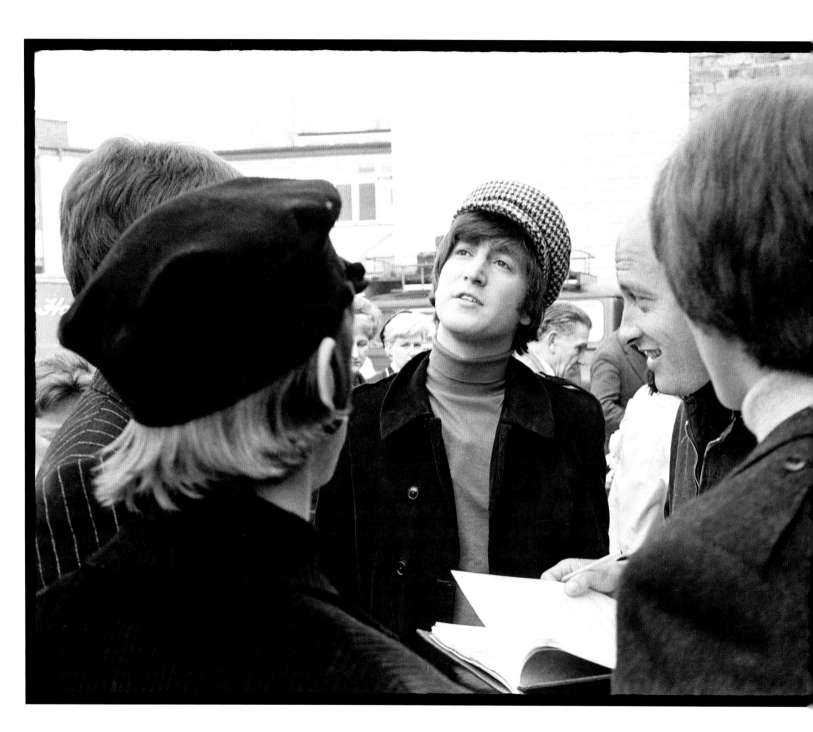

INTRODUCTION by Richard Lester

Sometimes, as a film director, you find that the publicity department of your project has assigned a freelance still photographer to cover certain scenes. It is often likely that you know neither the photographer nor his work. Sometime later, after shooting is done, you get to see contact sheets of his time on your set. In some cases, you look at the photos and think, "What film was he on?" his vision being so foreign to your own. In other cases, you say to yourself, "Why were his setups so much more interesting than mine?" I can happily say that the author of this collection falls in the latter group, and gives me the pleasure of reliving very happy times of some fifty years ago.

EIGHT ARMS TO HOLD YOU by Alastair Gordon

London, 1964: "It was raining that afternoon and my English wasn't very good," said Emilio Lari, the Italian photographer who was recalling the mood that day in February of 1964, when he first arrived in London, twenty-four years old and filled with wild-eyed ambition. Someone had told him that the American director Richard Lester was in town making a movie about the Beatles, and that he should try to get on the set.

"One day, I decided to drive my Fiat 500 all the way to London," said Lari. "I left from Largo Benedetto Marcello in Rome with my friend Mazzocchi, who kept boasting that he knew English, which he didn't." Lari and his friend shared a cheap hotel room in Soho and went out on the town every night. "He believed that all of the bands playing in Hyde Park were the Beatles since he thought the English for 'band' was *Beatles*."

Before leaving Rome, Lari had been an assistant photographer at the Cinecittà movie studios on the Via di Castel Romano, where he worked on Vittorio De Sica's *Yesterday, Today and Tomorrow* with Sophia Loren and Marcello Mastroianni. He'd also shot stills for *The Bobo*, which featured Britt Ekland and Peter Sellers, who played a singing matador.

Having arrived in London on an impulse, Lari now found himself searching the back streets of Chelsea for an address he'd scribbled on a scrap of paper the night before. He finally found the right house and rang the bell. Richard Lester, the director, opened the door, took one look at the sadly rain-soaked stranger and tried to close the door again. Lari stood firm, stuck his foot on the sill, and explained how he was a professional photographer from Italy, on assignment for a major magazine. "My English was very bad so I tried speaking to him in broken French and I lied to him in French."

Lester knew that it was probably all a tall tale, but he was charmed by the young Italian's persistence and invited him to come shoot on his set the following morning. Lari went off

Emilio Lari photographs himself and his friend Mazzocchi in the mirror of a hotel room, soon after arriving in London in February of 1964. A few days later, Lari found himself shooting stills on the set of *A Hard Day's Night*.

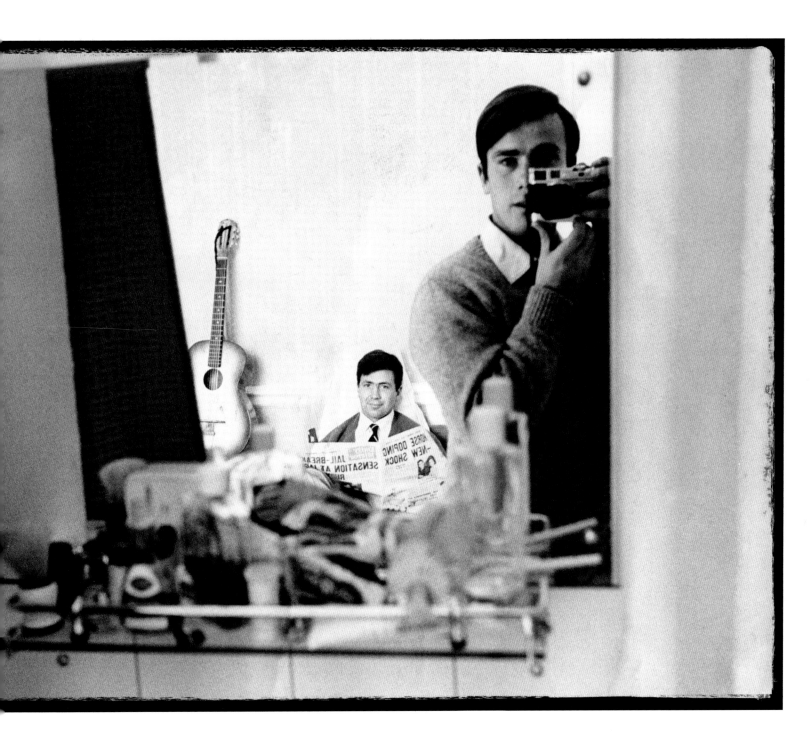

to eat fish and chips, but parked his Fiat in front of Lester's gate, just to make sure the director wouldn't leave without him. The next morning, at dawn (March 2, 1964), Lari was awakened by a tapping on his fogged-up windscreen; it was Lester telling him to follow his car to Marylebone Station, where they were scheduled to be shooting the Beatles in the opening scenes of *A Hard Day's Night.*

Marylebone is a Victorian-era station with pointy gables and soot-stained brick walls. It had been selected as a stand-in for Paddington Station because Paddington would have been too crowded. When Lari and Lester arrived they were walking arm in arm so everyone on the crew assumed that the photographer must be an old friend and they never bothered him.

Lari worked quickly, shooting with his Leica M2 and occasionally switching over to a Hasselblad 500C, hovering close behind Lester, who gave instructions to John, George, and Ringo as they ran down railway platforms, leaped over barriers, and crouched down in a photo booth, all while being pursued by a mob of hysterical fans—mainly adolescent schoolgirls—who had been hired as extras.

"I was mesmerized by the Beatles," said Lari. "They were so elegant. I loved their style." Meanwhile, Paul was inside the station, sitting on a bench beside Wilfrid Brambell, the Irish actor who played his fictional grandfather.

Sometimes it was hard to tell the extras from the fans who had managed to penetrate the perimeter of the set and were mixing with the paid extras and continued to harass the lads even after Lester shouted "Cut!" Lari was well suited for all the mayhem that played out that day. He'd been a champion rugby player in Italy and had no trouble running alongside the Beatles as they darted through the station, using his body weight to break through a line of crazed female fans. "On a rugby field you learn how to confront anything, constantly," said the photographer. "You always know what's going to happen a second beforehand. On a movie set, the same thing happens."

By late afternoon, the magic was over and Lari was asked to leave the set. Dave Thompson, the official photographer,

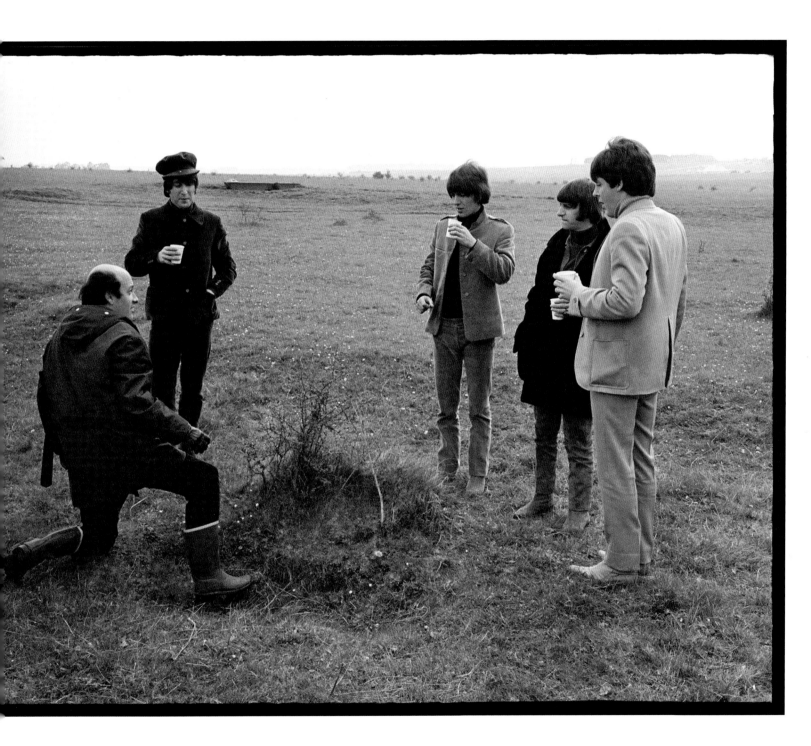

had arrived and didn't want any competition. But Lester liked Lari's photos and promised he'd consider using him on a future project. "After that first day on *A Hard Day's Night*, I felt I could do anything," said Lari, who realized that this might have been the luckiest break of his career. He'd shot ten rolls of film at Marylebone that day and took the images to Frank Selby at Rex Features, a photographic press agency. By the next morning, many of the shots were plastered on the front pages of the London tabloids. Some were later sold to an editor who published a novelization of *A Hard Day's Night*, which was written by John Burke.

It was an intoxicating time to be in London and over the next few months Lari threw himself into the thick of things, photographing street fashion, parties, and rock clubs. "It was so crazy, so free," he said. "King's Road was a fashion parade and no one cared if you dyed your hair or wore the most bizarre hat." It was the time of Twiggy and Jean Shrimpton, the miniskirt, Mods and Rockers, Marianne Faithfull, Carnaby Street, and fashion designer Mary Quant. "You could do or be whatever you liked," said Lari. "In Italy you were still expected to be married before you slept with a girl. In London, you went to bed with one girl and woke up with another." Hot young fashion photographers like Brian Duffy and David Bailey were being immortalized by the press and in the movie *Blow-Up*, Michelangelo Antonioni's homage to Swinging London, which was being shot that same summer. Lari fit right in. He dressed in a crushed velvet suit and grew his hair shoulder length. "I looked like Tarzan." He even landed a job on the set of *Thunderball*, the James Bond thriller that starred Sean Connery.

Richard Lester was nothing if not prolific. Right after *A Hard Day's Night*, he directed a successful comedy called *The Knack . . . and How to Get It*, which starred Rita Tushingham. Now, with hardly a day to spare, he started work on another pop extravaganza. This, the second Beatles feature, was intended to be a sequel to *A Hard Day's Night* but with a substantially larger budget ($1.5 million) and a much more ambitious shooting schedule. Originally called *Eight Arms to Hold You*, it was directed

Richard Lester coaches George Harrison on how to leap off a stepladder with arms and legs outspread. This iconic image was used for promoting *A Hard Day's Night*, which was released while Lester and the Beatles were shooting *Help!*

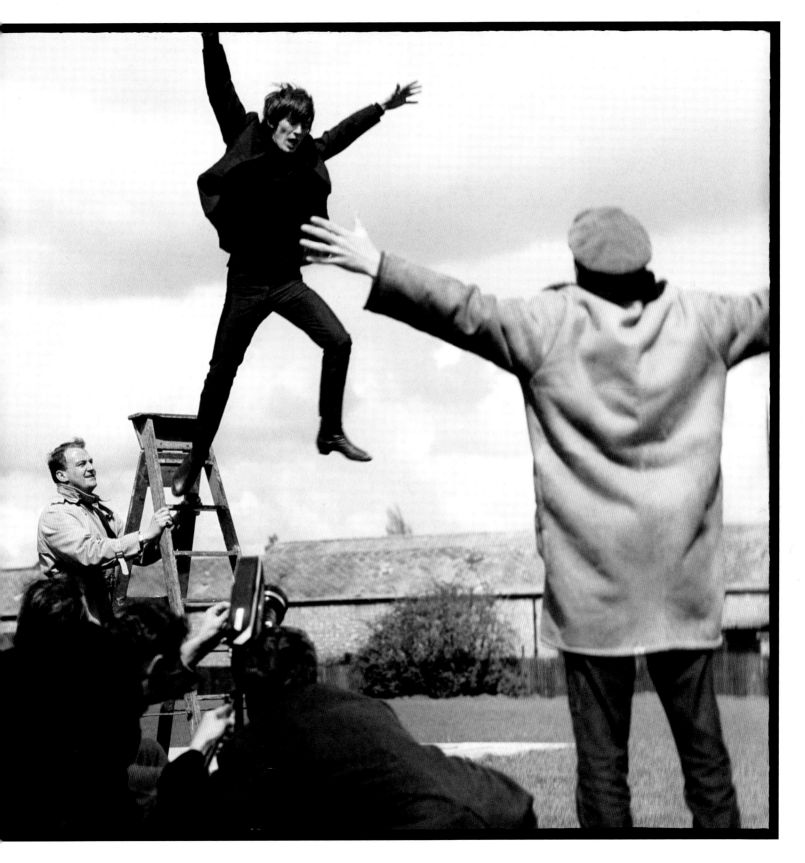

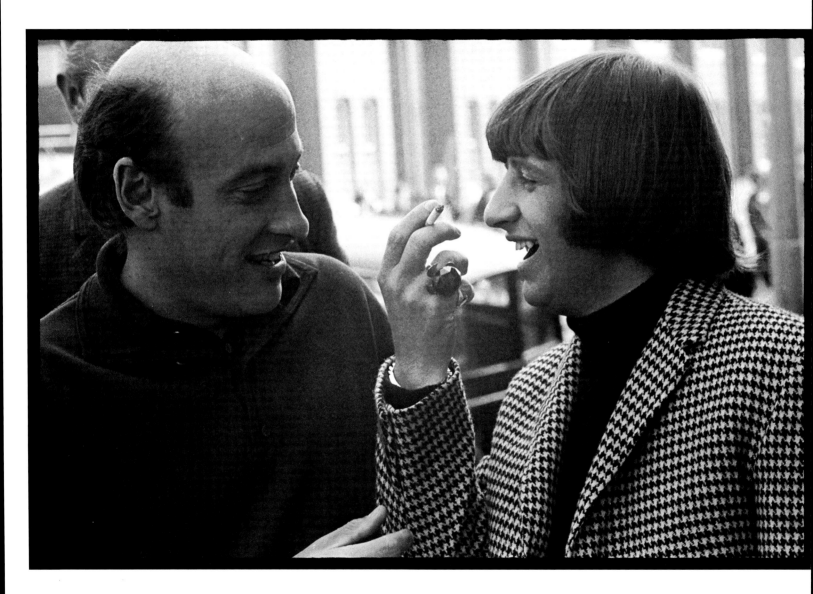

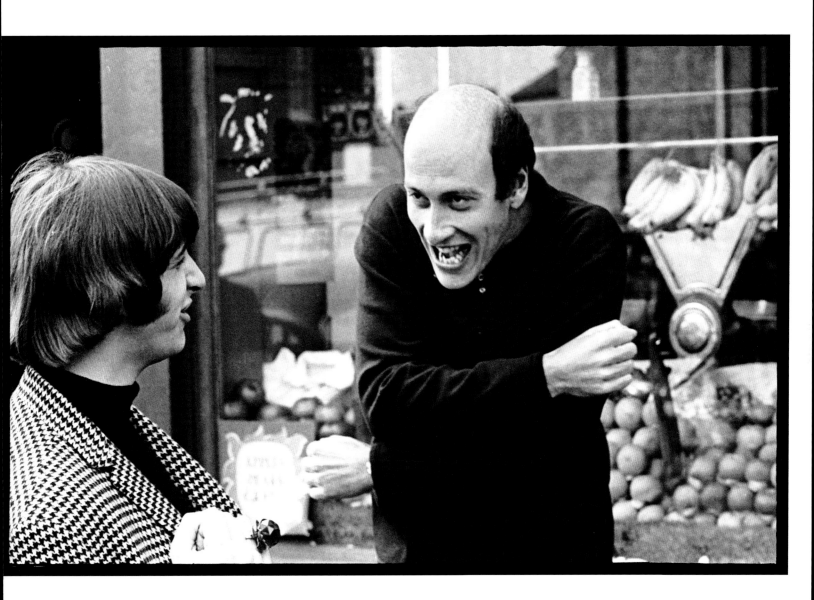

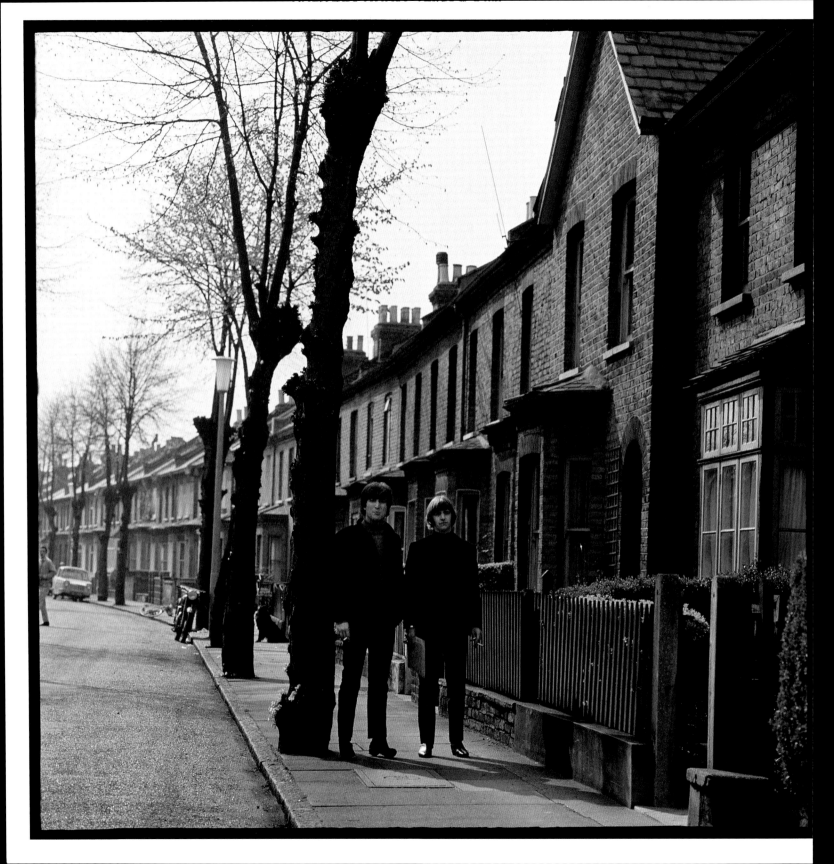

by Lester and produced by Walter Shenson, with cinematography by David Watkin. In contrast to the gritty, black-and-white documentary style of the first film, this was to be more of a comic-book fantasy rendered in bright colors and fast-cutting montages.

The plot was largely inspired by the irrational antics of *The Goon Show* and the Marx Brothers' *Duck Soup*, while poking fun at the then-current crop of Bond films that were also distributed by United Artists. The screenplay was written by English playwright Charles Wood, who'd penned *The Knack . . . and How to Get It* for Lester earlier that year. Wood's co-writer was American Marc Behm, best known for *The Party's Over*, a dark tale of Swinging London that starred Oliver Reed.

In the script, a fan has sent Ringo a large ruby ring that turns out to be the "dreaded sacred sacrificial ring of the dread Kaili." Whosoever wears the ring must be sacrificed to Kaili, the eight-armed goddess of wickedness. Unaware of this, the four lads go about their days, clueless, making music and larking about the streets of London, all the while being pursued by the Kaili cult that wants their mystical ring back. The problem is that Ringo can't get it off his index finger, so the high priest Clang (played by Leo McKern) has to devise ever more outlandish schemes to retrieve the ring, either by cutting off Ringo's finger or making a sacrifice out of the drummer.

The movie was shot on location in several faraway settings, but most of it would be filmed at Twickenham Film Studios in London. In February 1965, Lester set off for the Bahamas with the Beatles, cast, and crew—seventy-eight in all—flying from Heathrow to Nassau in a chartered Boeing. The Beatles rode bikes around New Providence and were allowed some sightseeing and swimming but it was unusually cold for the islands so most of the time they lay around, waiting.

After ten days in the Bahamas, the Beatles flew to Austria, where they shot a number of scenes, tumbling down the slopes of Obertauern, learning to ski, sledding a toboggan, riding in a horse-drawn sleigh, and hanging out in an après-ski club. By March 24, the Beatles and film crew were back in London shooting

John and Ringo wait for directions from Richard Lester. They are standing on Ailsa Avenue, not far from Twickenham Film Studios on Tuesday, April 20, 1965.

new scenes at Twickenham Film Studios, where most of *A Hard Day's Night* had been shot the year before.

Lester had changed the name of the film to "Help," but there was concern since another company had already registered that title. It was only when the producer's legal team suggested adding an exclamation mark—as in *"Help!"*—that they were able to claim it for their own. Later in the week, John and Paul stayed up all night writing the title song.

Around this time Emilio Lari got a call from Lester's publicity department, asking him to shoot stills on the film. On Wednesday, April 14, he met Lester and the crew on Ailsa Avenue, a few blocks from Twickenham Film Studios. It was an everyday street with terraced houses, bay windows, and small, fenced-in gardens. "We wanted this sense from the public that they were just four good Liverpool working-class lads trying to make a living," said Richard Lester.

In the movie, an elongated Rolls-Royce pulls up and the four lads climb out.

"Wave at them," says the older of two women standing on the sidewalk.

"Shall I? They expect it, don't they?" says her friend.

The boys wave back and walk up to their respective houses at No. 5, No. 7, No. 9, and No. 11 Ailsa Avenue, each door painted a different color.

"Lovely lads and so natural," says the older woman. "I mean, adoration 'as not gone to their heads one jot, 'as it?"

As the Beatles enter, the scene cuts to an elaborate interior set, a single communal space—the ultimate bachelor pad—with a shag carpet and swooping modern furniture, all designed by art director Raymond Simm and built on a sound stage in Studio #2 at Twickenham.

"Inside was total lunacy," according to Lester. Every section was color-coordinated for each individual Beatle. George's area was bright green with grass carpeting and a Swiss shepherd who proceeded to clip back the grass with a pair of chattering false teeth. Ringo pulled snack food out of a vending machine while Paul played a tune on a Wurlitzer organ with blinking lights that

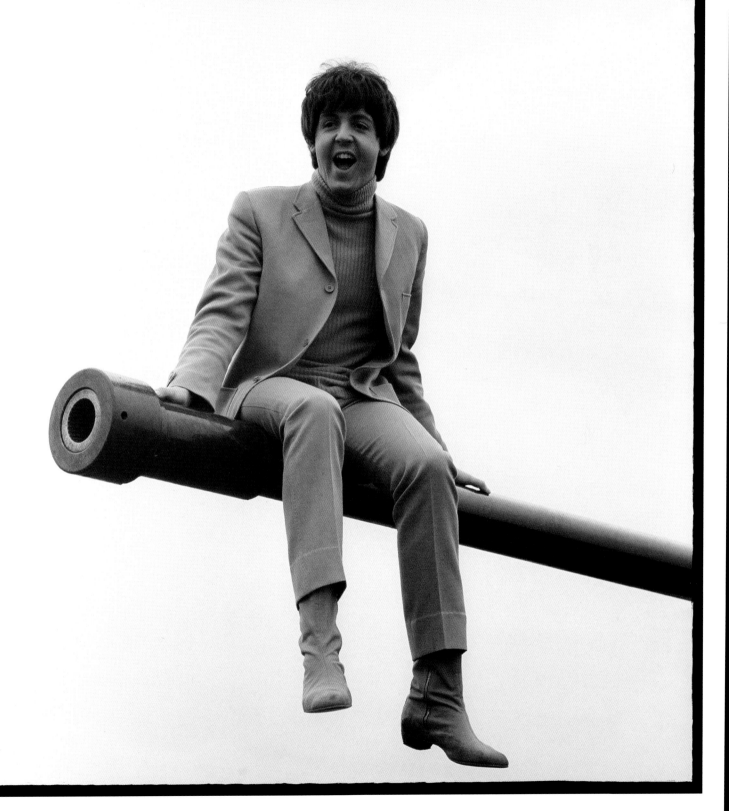

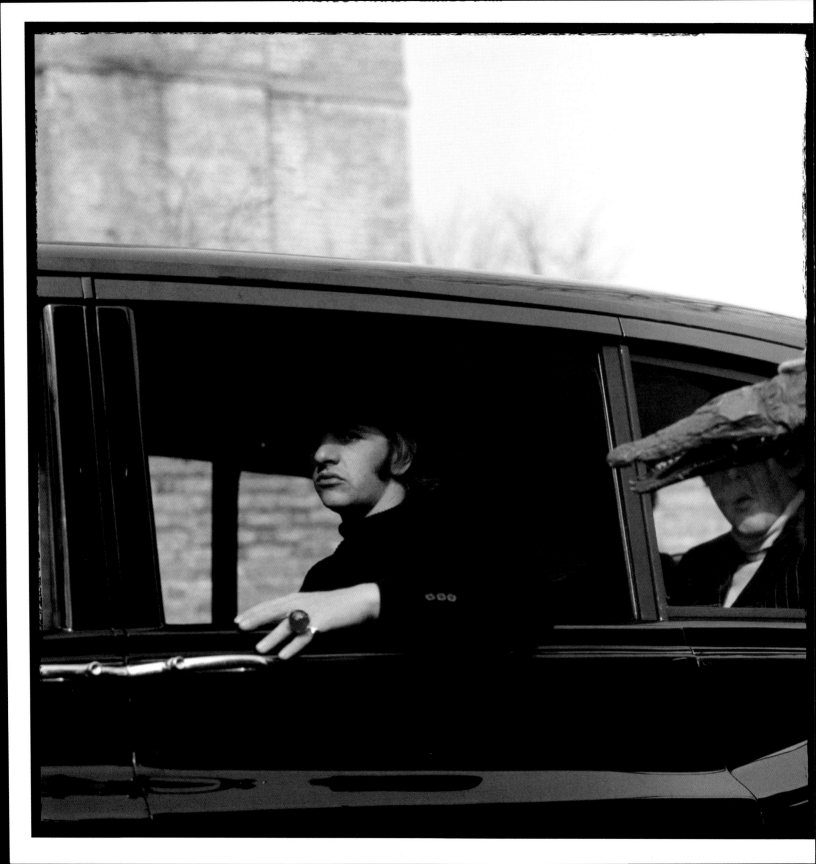

arose slowly from a lower level. John meanwhile searched the bookshelves to find a hidden copy of his book, *In His Own Write*, kissed the cover, and dove into the sunken bed.

"*Direttore* Lester was very kind and patient with everyone," said Lari. "He never yelled at anyone. He loved the camera and seemed more like a cinematographer than a director. He was always looking through the lens, setting up the next shot."

The scenes in the communal room took several days to film and Lari was everywhere, trying to catch as much as he could. He was fast on his feet and often got shots that the other photographer on the set, Michael Peto, missed. Lari employed a device called Leicavit so that he could click the shutter with his right hand while, with his left hand, he forwarded the film with a manual clutch. "It allowed me to take many more shots," he said.

Indeed, he took thousands of pictures from every conceivable vantage point, getting as close to the action as he could, working his way behind the cameraman, wedging himself between Lester and the assistant director, crawling on the floor for a better angle. At one point Lester turned to him and joked, "If you want to be in the shot you're going to have to go to makeup first!"

Lester may have had a bigger budget for *Help!*, but he was on a very tight schedule and would often shoot as many as forty scenes a day. "The boys were getting exhausted," recalled Lari. They were not only acting in the movie all day, but they were writing new songs as well as making appearances on television and radio shows. They were tired, often stoned and giddy. In some of the final scenes you can see it in their faces. Lester would say, "now, boys, can we do it again?" and they would start all over again on a certain scene but they frequently lost their concentration. "When you go to bed at three a.m., it's hard to get up at six a.m.," said John. "You see, we're night owls."

When he first met them on the set of *A Hard Day's Night*, they'd all looked the same to Lari, the same shaggy hair, the same slender figures, always moving in a blur, ducking in and out of doorways, never still, pursued by adoring fans. But as he spent more time with them he got to know their individual traits

and soon learned just how different they were from one another. "John was surprisingly serious," said Lari. "Paul was the clown who knew how to strike a pose. George was also serious and could at times be moody, but most of the time he just wanted to sleep. Ringo was always fun to be with."

The natural talents of the Beatles may have been better suited to the gritty documentary style of their first film because they were, essentially, playing themselves. There's not quite the same easy-going flow in *Help!*, nor is there a sense of their getting into the characters as written in the script. They often seem distracted, half asleep, and they probably were.

"With *A Hard Day's Night*, we had a lot of input, and it was semi-realistic," said John Lennon. "But with *Help!*, Dick Lester didn't tell us what it was all about. He never explained it to us." Paul McCartney felt equally disconnected from the day-to-day production process. "We had really tried to get involved and learn the script for *A Hard Day's Night*, but by the time *Help!* came along we were taking it as a bit of a joke," he said. "I'm not sure anyone ever knew the script. I think we used to learn it on the way to the set."

But whenever the music started up again, the Beatles slipped back into their element: John in a black leather chair playing a twelve-string guitar, singing "You've Got to Hide Your Love Away"; George sitting on the couch beside Ahme (actress Eleanor Bron), playing a six-string; Paul playing bass and Ringo sitting in the bed pit, jingling and whacking away at a tambourine. "There was so much energy on the set. That's what I liked," said Lari. Between takes, he took shots of John tuning his twelve-string guitar, Paul reading a comic book or lighting a cigarette, sucking the smoke back through his nostrils.

Lari loved to hang out with them, chatting and smoking, catching them off guard whenever possible. "You must learn to be discreet and understand when the moment to disappear has come," he said. "But you are never truly invisible." He followed them into the parking lot and down the back corridors of Studio #2 when they were taking tea breaks. That was when Lari got some of his best shots, when they were clowning around, off

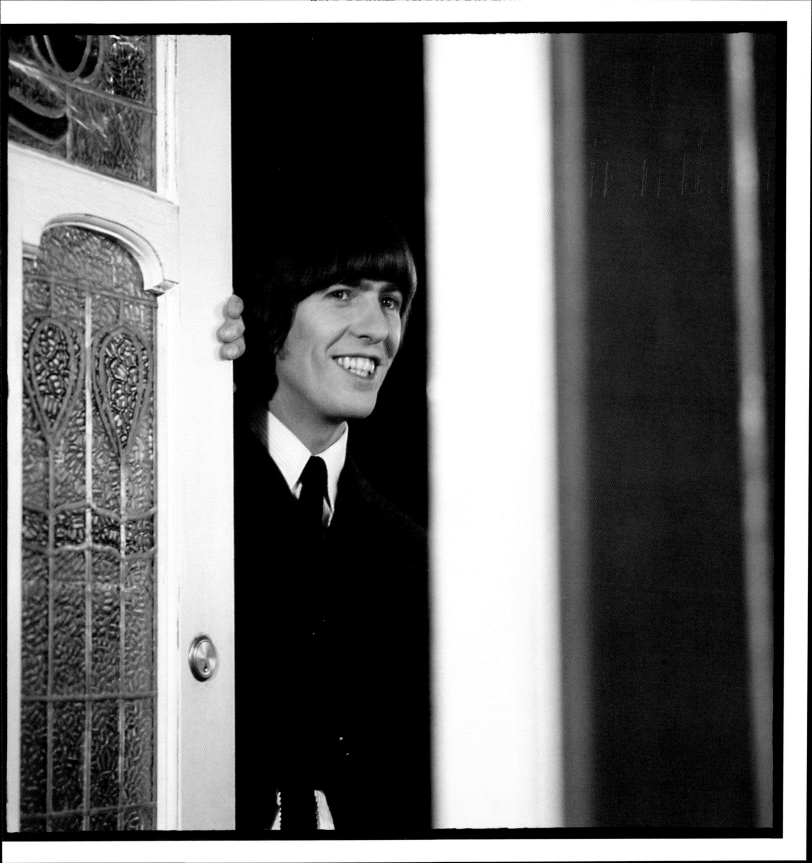

set, "taking the piss," like the time John donned a woman's wig with a bow from the costume department and posed, raising his hand in the peace, or victory, sign (pp. 64-65).

They spent long periods just waiting around, making jokes, reading the newspapers, and drinking coffee. Soon, they were getting bored with the process and afternoon shooting became almost impossible. "The whole film had a kind of mad quality to it, and this was probably helped by the fact that an awful lot of pot was being smoked," admitted Lester. "Nobody could communicate with us; it was all glazed eyes," said John. "We giggled a lot," said Paul.

> *"The purple plain of Salisbury was at*
> *its most beautiful and most purple in*
> *the early morning light as the boys arrived."*
> —Al Hine

On Sunday evening, May 2, the Beatles reached Amesbury, a historic town in Wiltshire, about ninety miles west of London. They arrived at 11:20 p.m. and checked into the Antrobus Arms Hotel at 15 Church Street. One of the final sequences of *Help!* was being shot on nearby Salisbury Plain and every morning the band would be driven from the hotel to the set in a black Austin Princess limousine. Their comings and goings attracted mobs of teenage girls who would block all the streets through Amesbury.

Most of the filming was done at Knighton Down in Larkhill, only about a mile north of the ancient site of Stonehenge. It was within a military reserve so that Lester didn't have to worry about crazed fans. "By using Salisbury Plain we were in a military area and there was nobody getting in the way, nobody running into the frame," he said.

Emilio Lari was out there early, running back and forth with four Leicas and a Hasselblad strapped around his neck, ready for almost anything. "At the beginning we were in the middle of the field, with all the instruments, while the boys were singing at the top of their voices," he said. There were speakers, microphone stands, booms, a mixing table, and even the partial section of

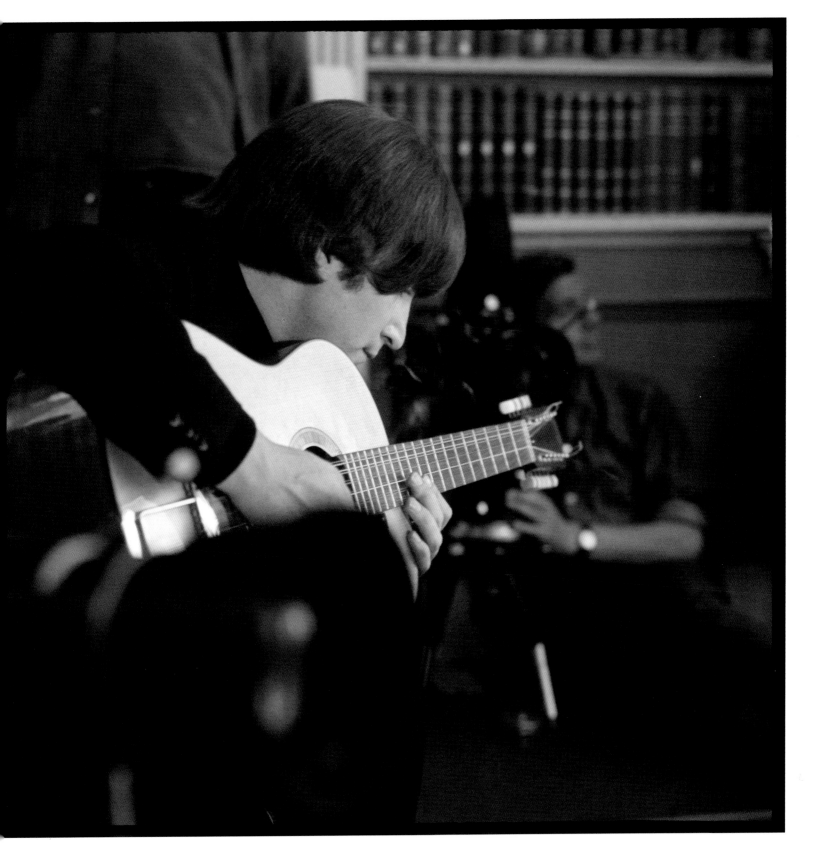

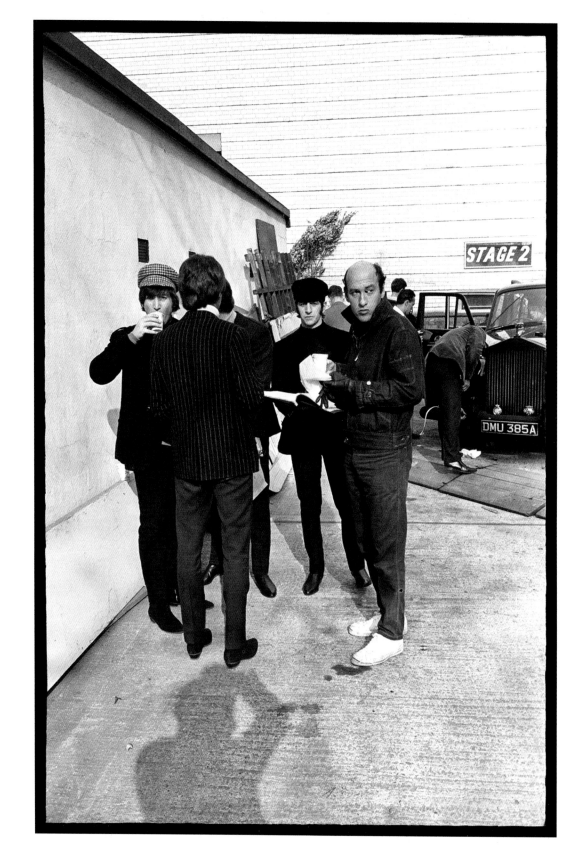

a control booth, which had been assembled that morning on an open stretch near Silk Road.

The Beatles stood on the windswept plain, dressed in military-style suits designed by Julie Harris. George was lip-synching his song "I Need You" in the improvised recording studio, a helicopter was hovering overhead, and John was playing a piano. They were surrounded by seven Centurion tanks from the Third Division of the Royal Artillery, who were on exercises in the area that week, and actual infantry troops were used as extras in many of the scenes that day. Such was the Beatles' celebrity that even the British army agreed to accommodate their needs. "The army loved it," said Lester.

At one point Paul grabbed Lester's bullhorn and started making silly commands (pp. 108-09). George suddenly leaped onto the tank's cannon and wrapped his legs around the barrel, hanging there like a monkey (p. 127). John's humor sometimes had a dark underside and he took one of the soldier's guns and pointed it at his own head, pretending to pull the trigger. "I didn't like that at all," confessed Lari, who refused to shoot the gag.

Wednesday, May 5, was the last day of the Beatles' three-day shoot on Salisbury Plain and the weather was getting worse. "It was freezing and actually we may have pushed that a bit," admitted Lester. In the finished movie you can see Ringo's teeth chattering and his nose running red with the cold. Paul sings "The Night Before," then there's an explosion, and machine guns start firing. The boys are running hither and thither across the field, chased by one of the tanks driven by Ahme (Eleanor Bron), who welcomes them aboard. They hide inside a big haystack.

"The tanks were rolling back and forth, fake bombs exploding," said Lari. "There was an incredible energy, the loudspeakers booming out." During the break, Lari took a series of shots showing Paul burrowed inside the haystack, trying to warm up (pp. 110, 117). Lari also got a few shots of Ringo relaxing between takes wearing a borrowed peacoat over his brown suede jacket (pp. 89, 123).

The Beatles wanted to work with director Richard Lester because they'd seen and admired *The Running Jumping and Standing Still Film* (1960), a comedic short that Lester had made with Peter Sellers and Spike Milligan.

The next morning—Thursday, May 6—the Beatles checked out of the Antrobus Arms and returned to London by bus. They were back working the following morning, finishing up some of the final takes including the Buckingham Palace scenes that were shot at Cliveden, Lord Astor's estate in Buckinghamshire, and at Twickenham, where they shot "The Exciting Adventure of Paul on the Floor" sequence in which Paul gets accidentally shrunken down to mouse size and pulls a chewing gum wrapper around his naked body. Their final day of shooting was Tuesday, May 11.

Help! had its world premiere at the London Pavilion on Piccadilly Circus, on July 29, 1965, only two months and two weeks after the last day of filming. More than ten thousand fans were there to welcome the Beatles as they pulled up in a black Rolls-Royce. Inside the Pavilion, the group was greeted by Princess Margaret and Lord Snowdon. Richard Lester and the cast were also on hand, and after the screening, they all celebrated at the Orchid Room of the Dorchester Hotel. "We decided that if we win Oscars for this film, we're all going to send them back!" quipped John. The movie was a box-office smash and netted United Artists more than $12 million, while the title song rose to number one on virtually every music chart around the world.

Help! was the last time that Lari worked with the Beatles. He stayed in London for another year before returning to Italy, where he would work as a set photographer on many classic movies including *Barbarella*, the cult hit of 1966, Franco Zeffirelli's *Romeo and Juliet*, Francis Ford Coppola's *Godfather* trilogy, and Martin Scorsese's *Raging Bull*.

"It was my passion," said Lari, who is now semi-retired at seventy-six years old and continues to live in Rome. "You can learn something from each movie set, but the ability to synthesize everything into a single shot is natural," he said. "The rest is craft."

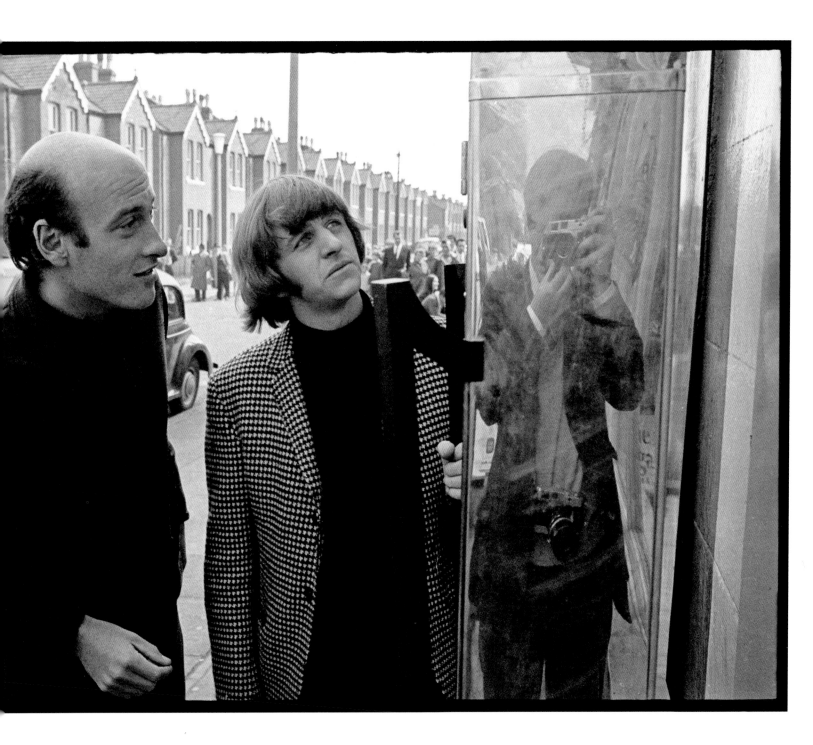

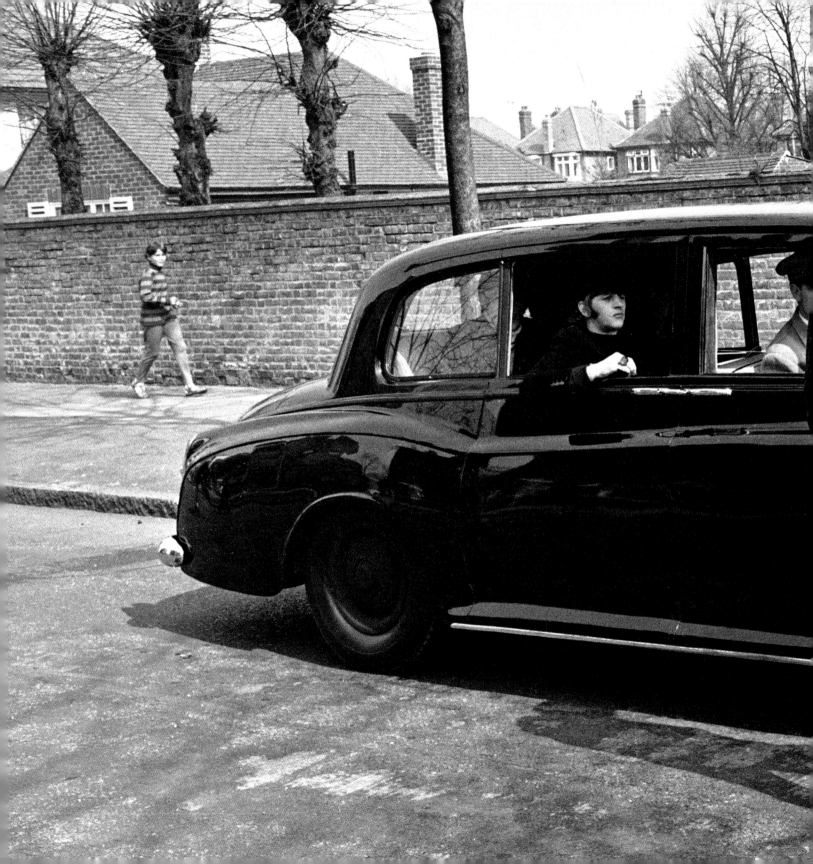

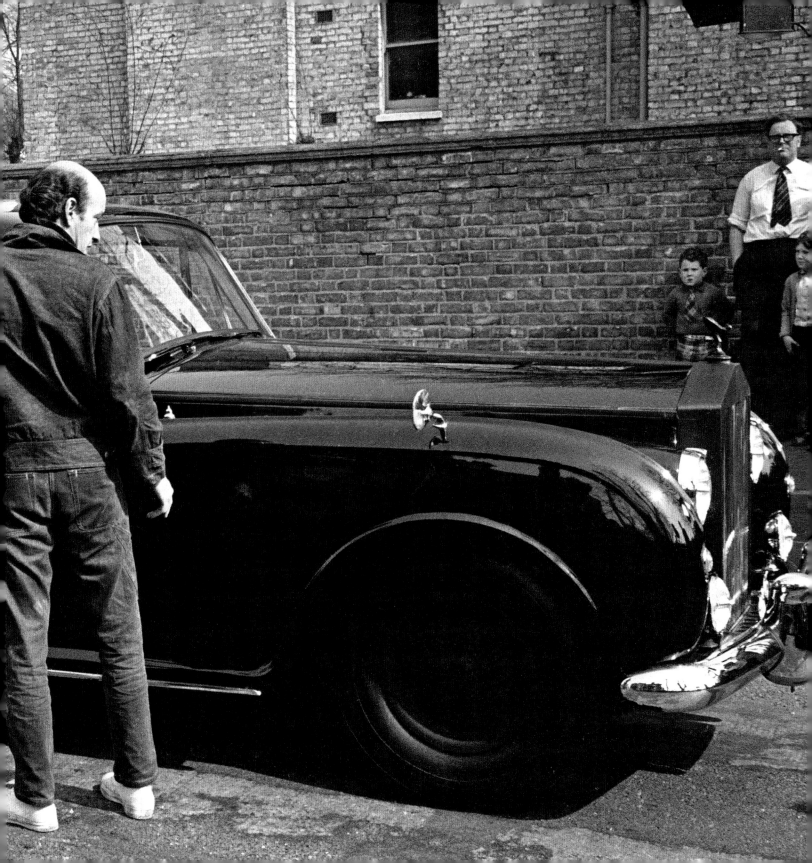

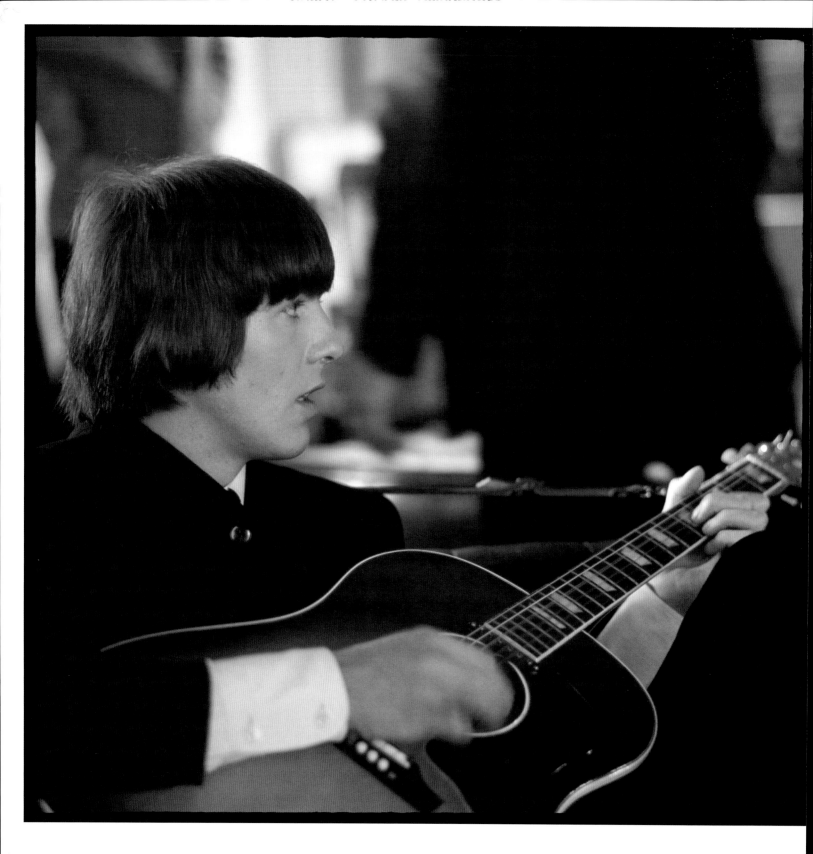

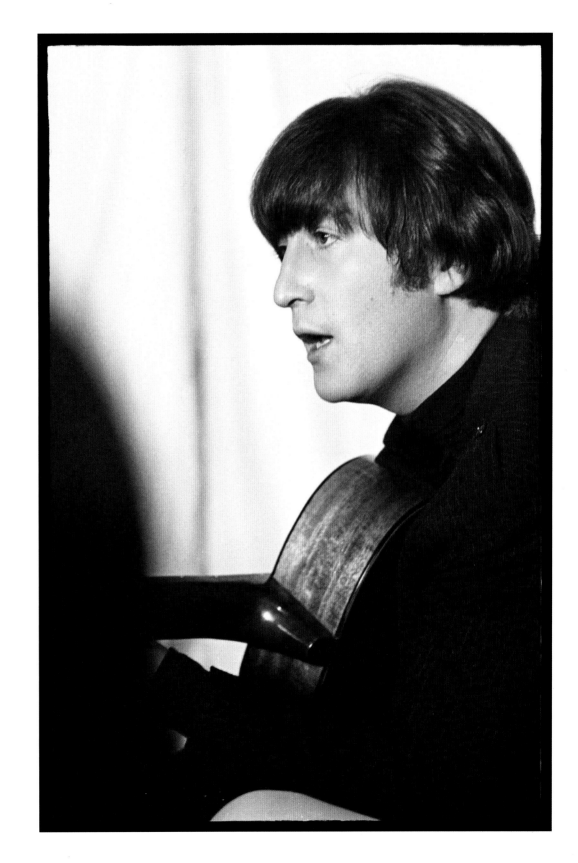

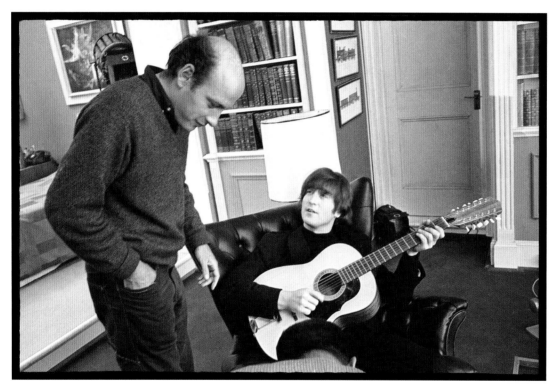

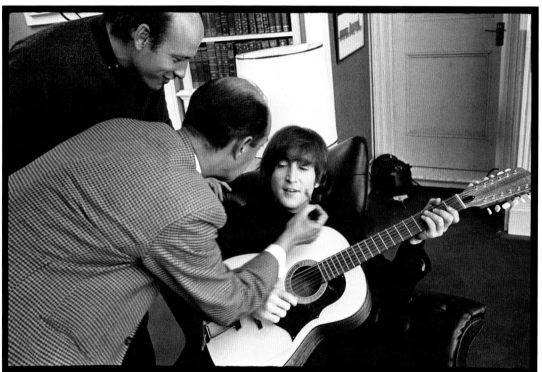

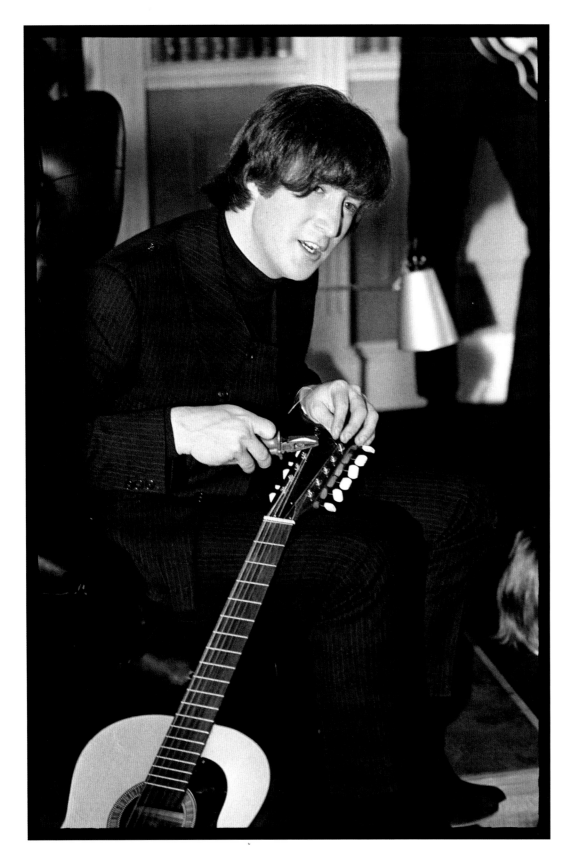

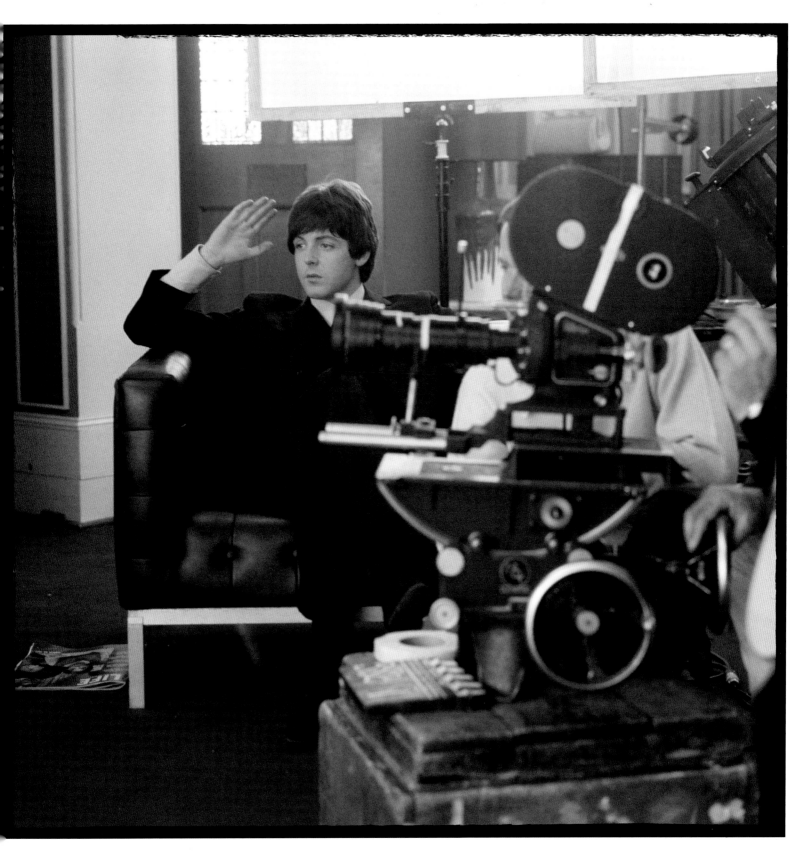

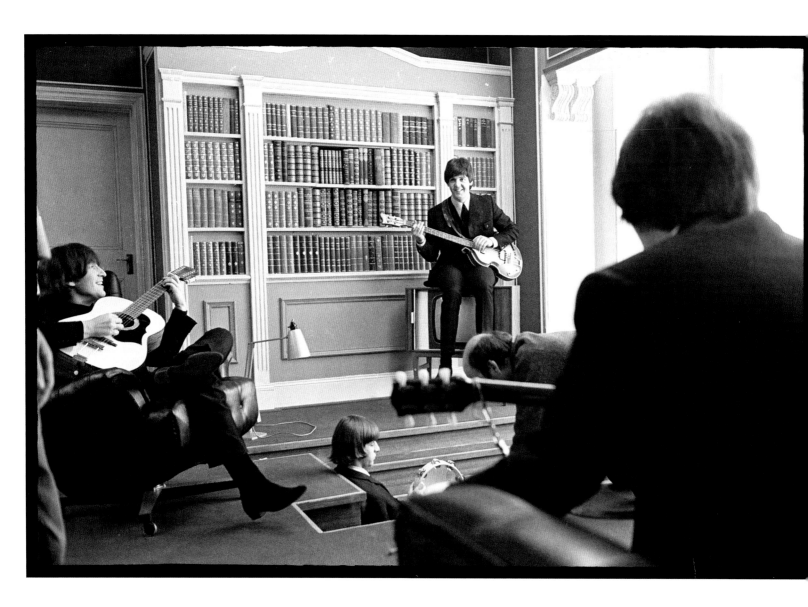

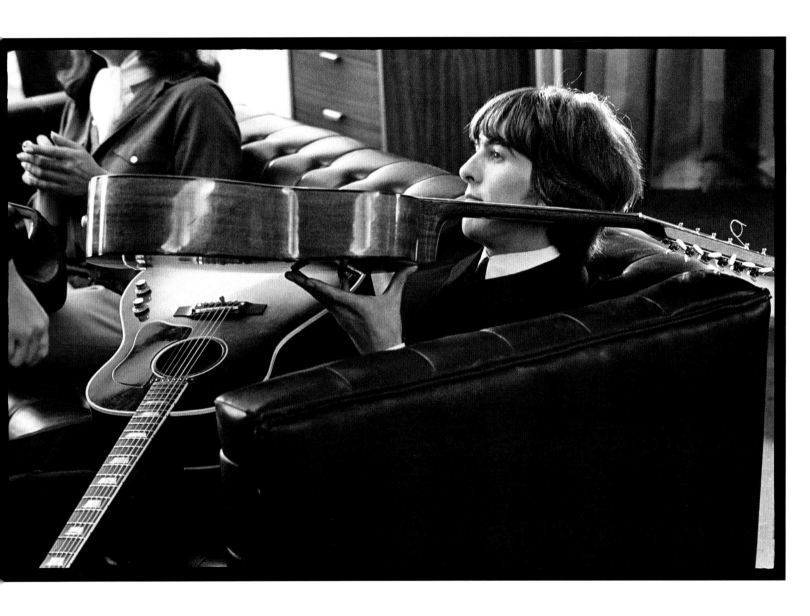

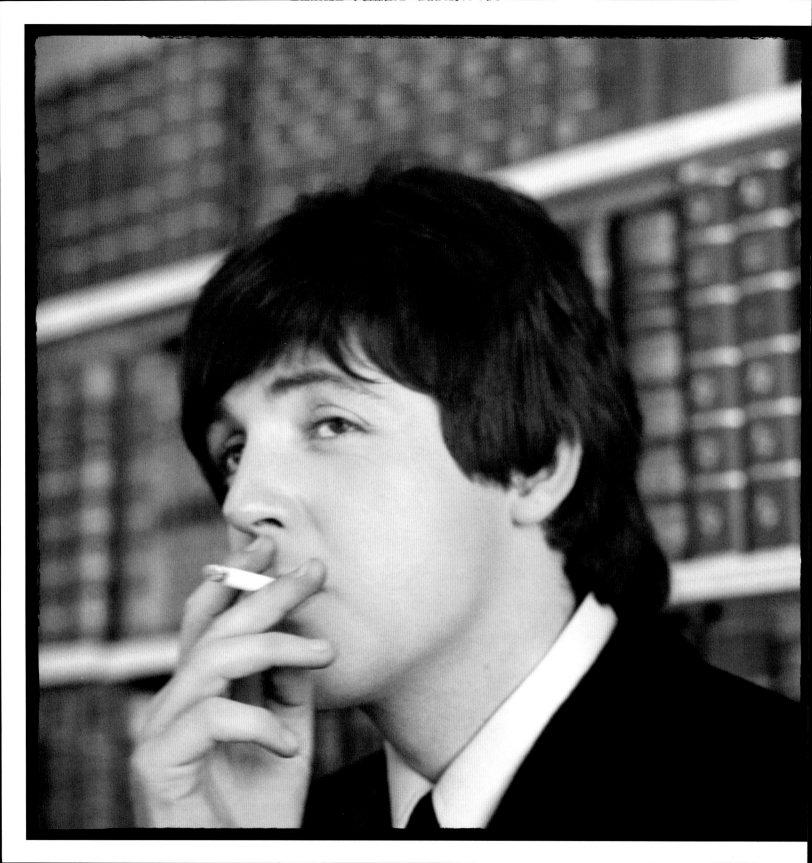

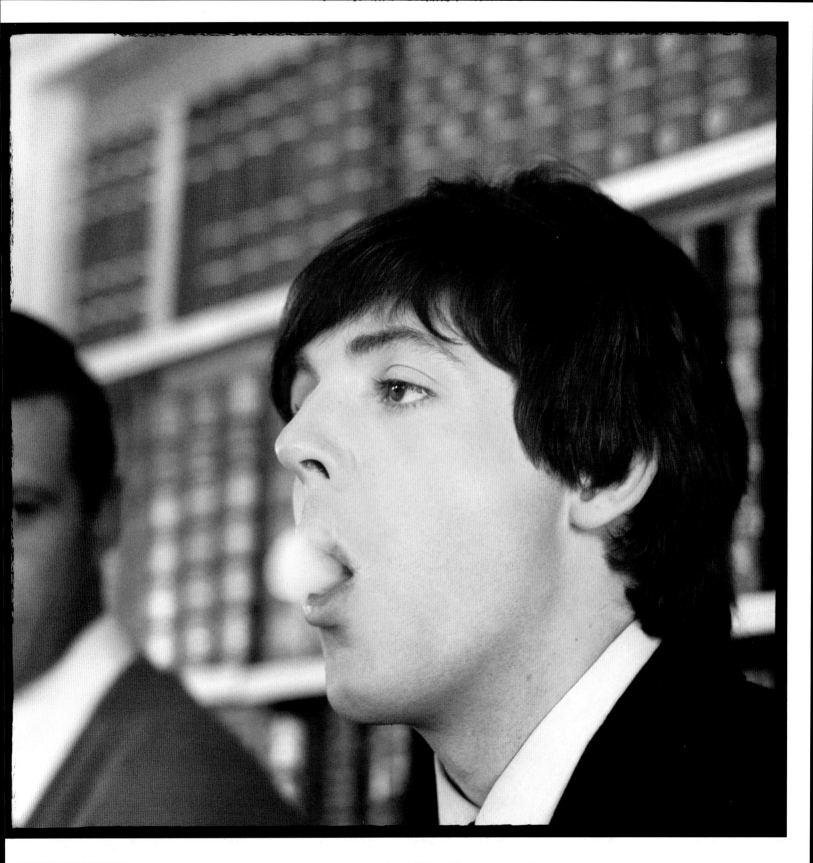

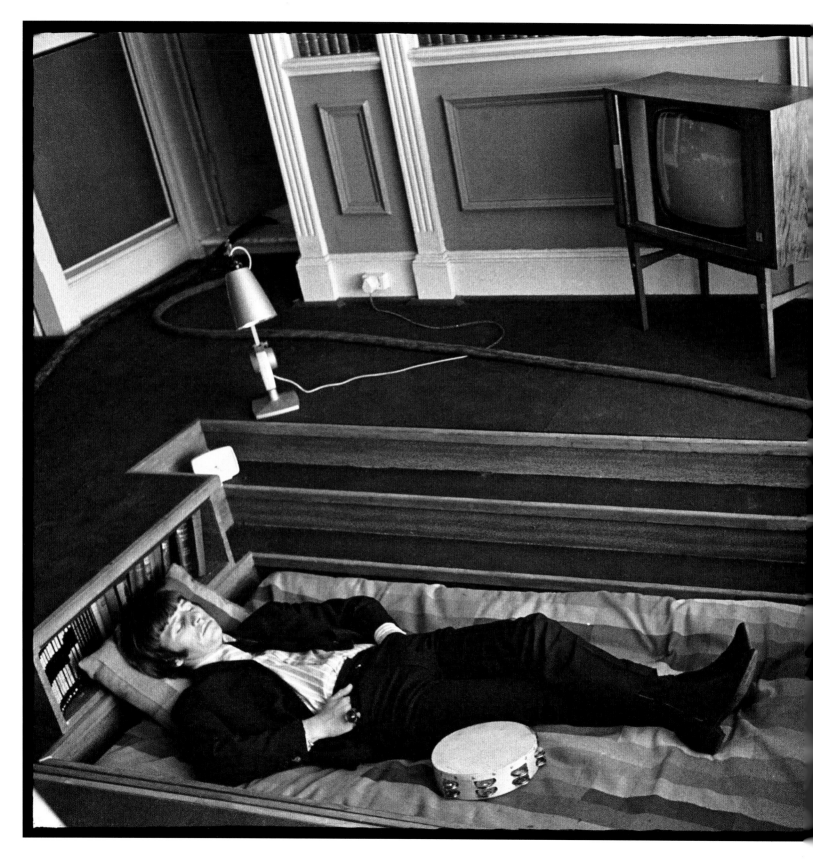

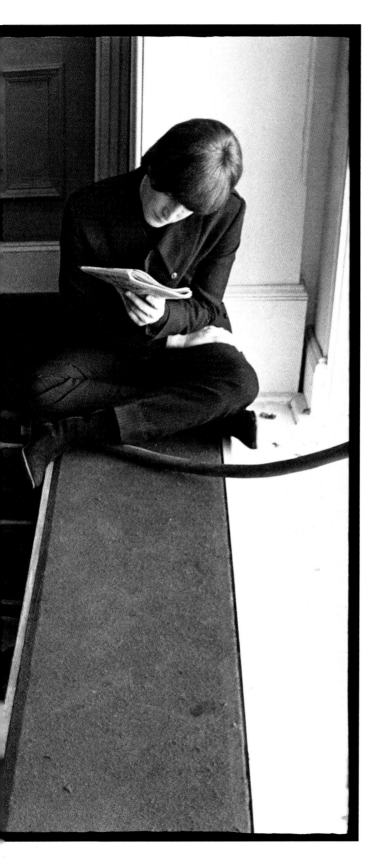

Between takes at Twickenham Film
Studios: Ringo takes a nap in the sunken
bed while John reads a comic book.
The bachelor-pad set was designed by
art director Raymond Simm complete
with color-coordinated walls, shag rugs,
vending machines, ultra-modern furniture,
and a psychedelic illuminated organ that
rose up from a subterranean pit.

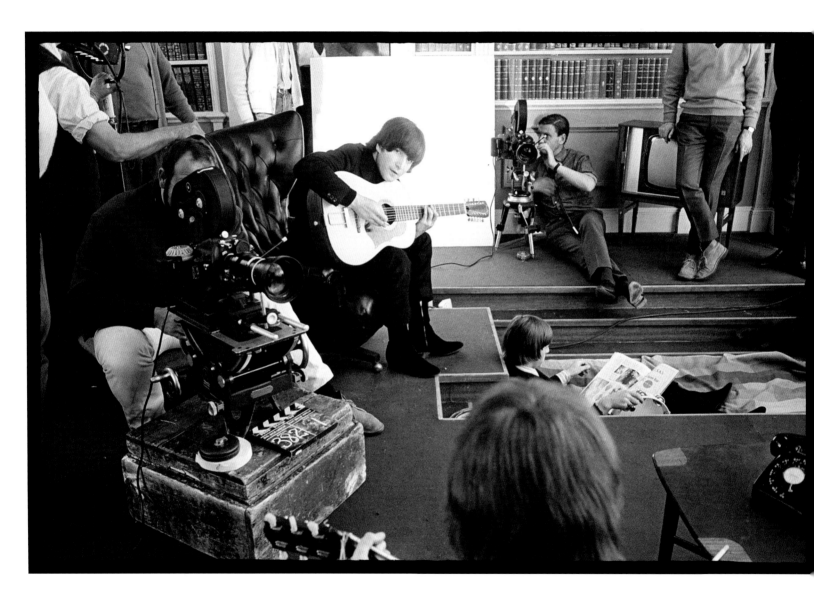

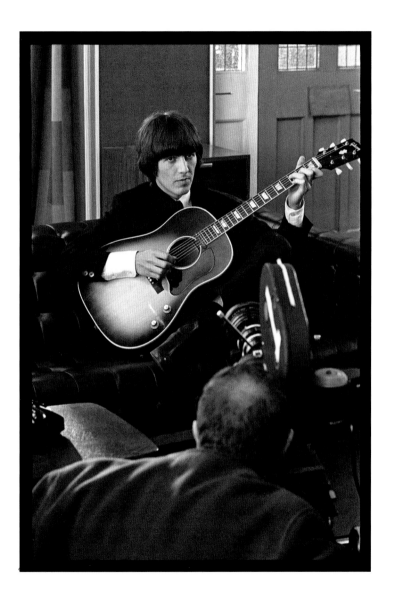

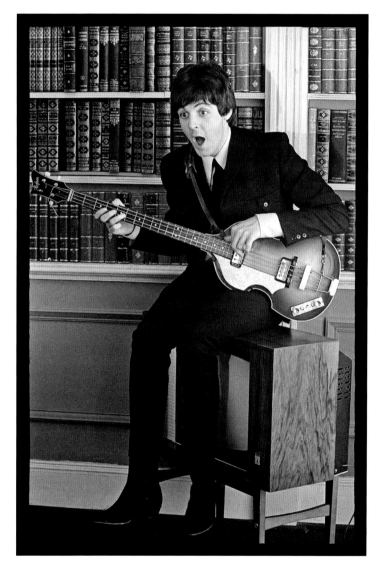

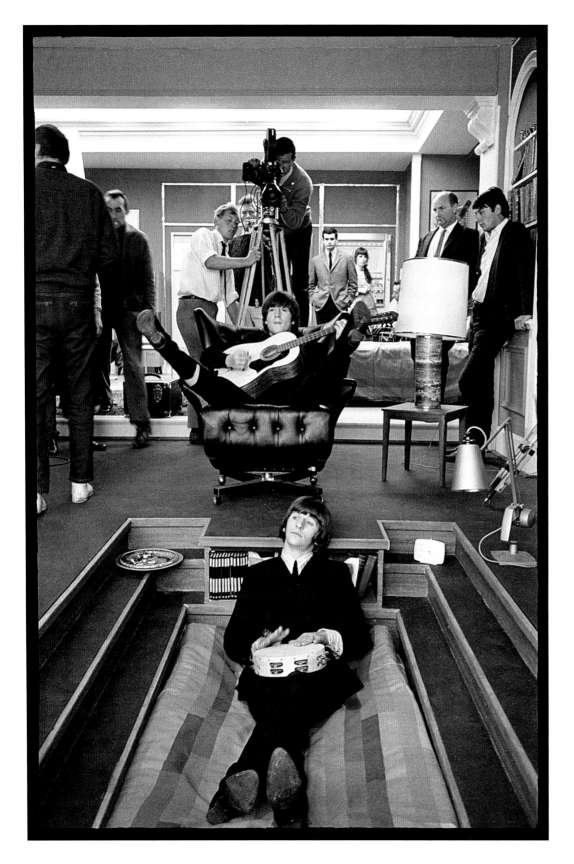

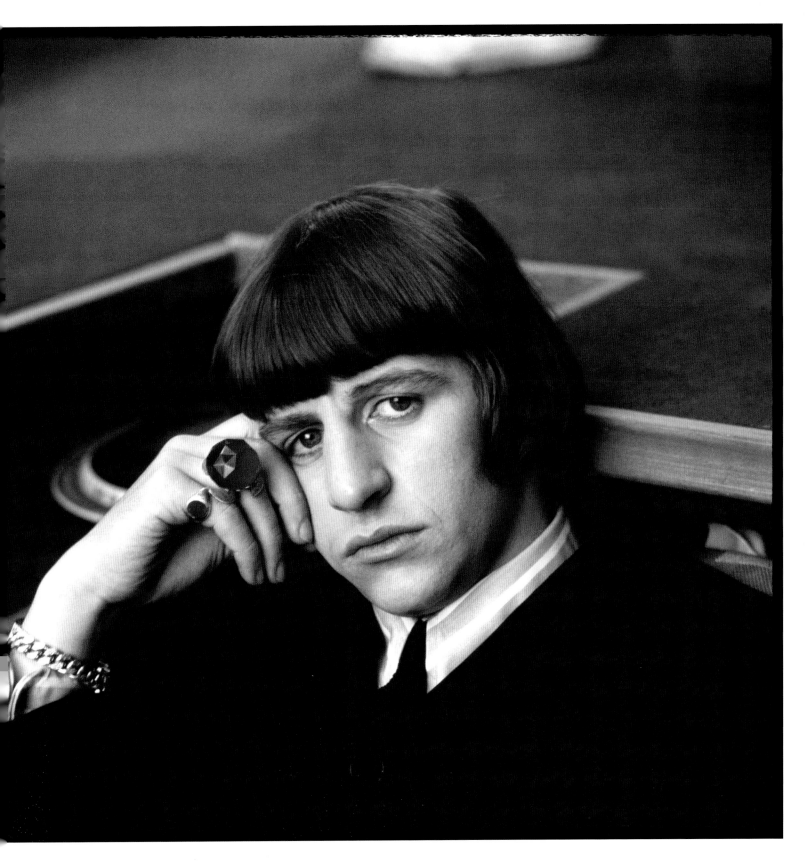

Paul pretends to play his Höfner 500/1
bass guitar like a violin, at Twickenham
Film Studios. There was a lot of waiting
around on the set, sleeping, reading,
practicing new songs, drinking coffee,
and smoking pot. "We giggled a lot,"
said Paul.

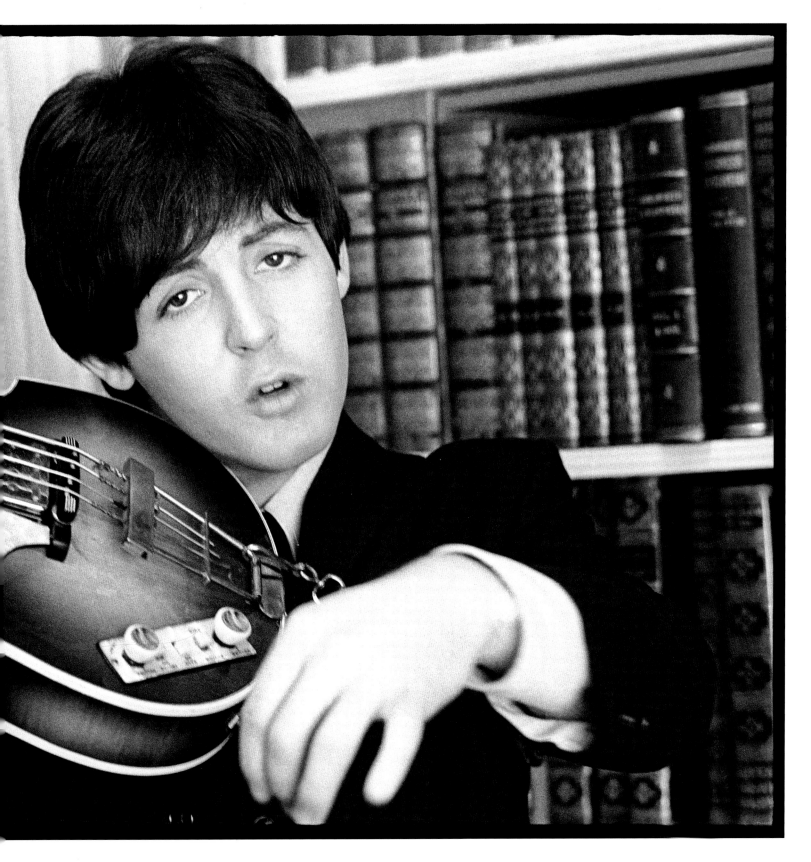

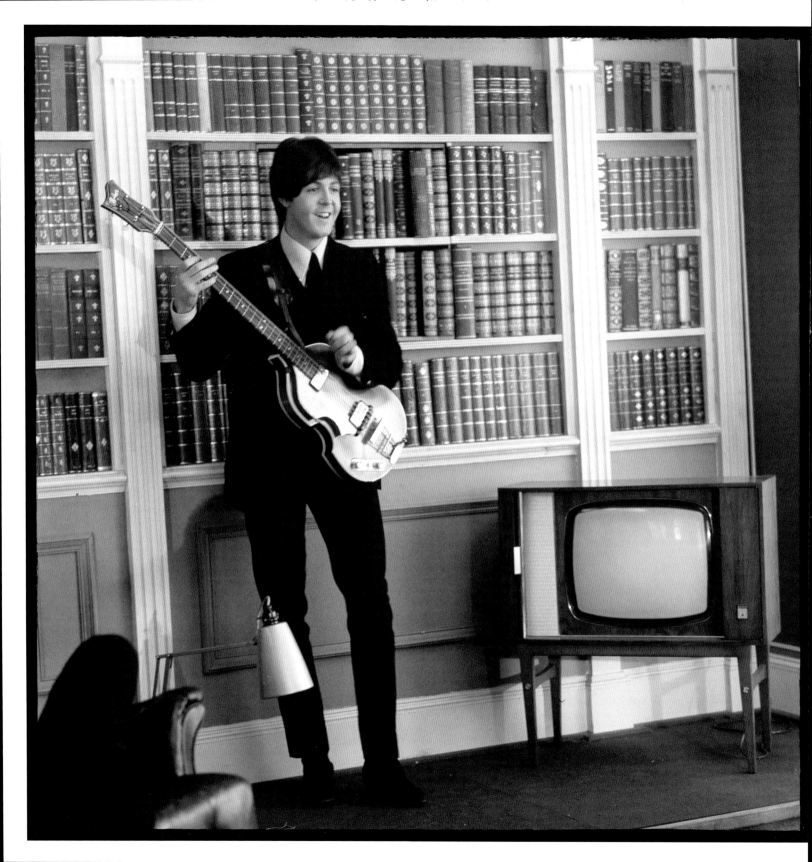

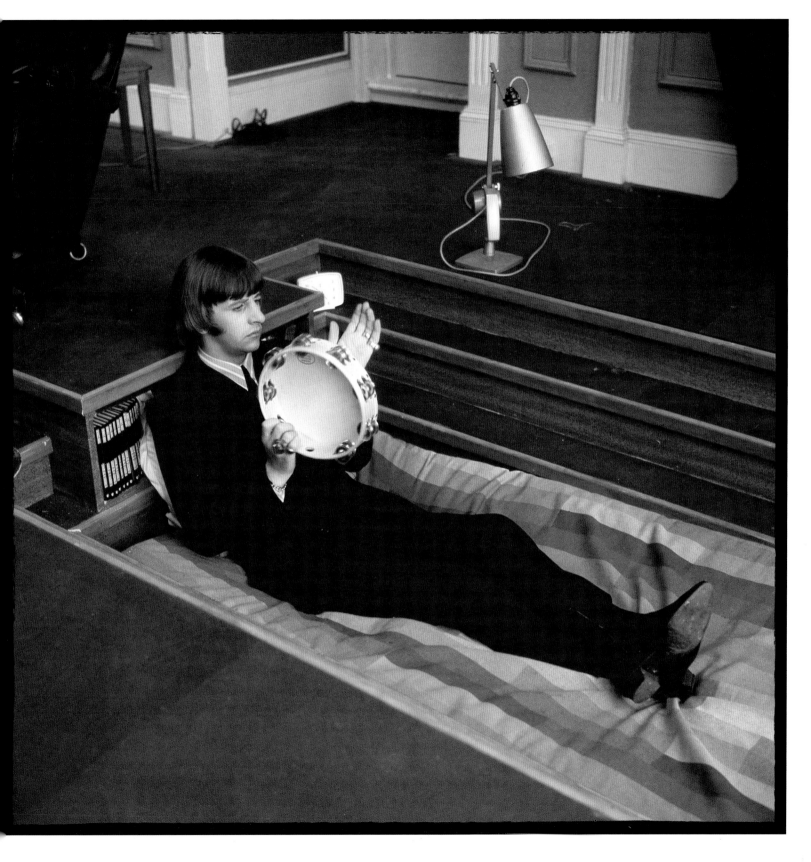

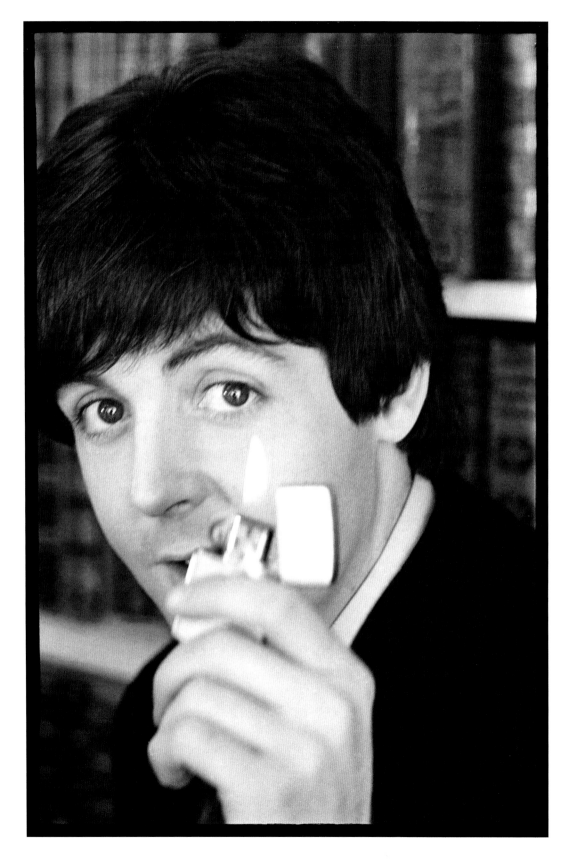

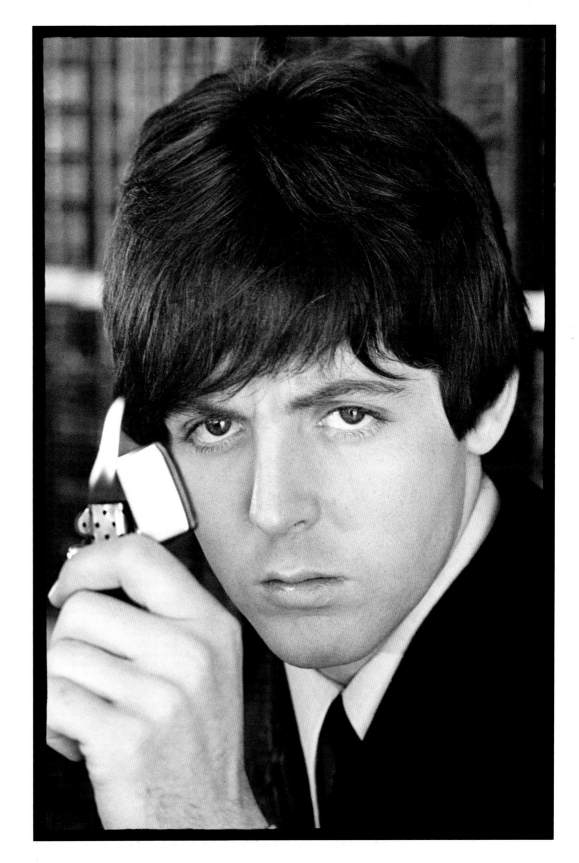

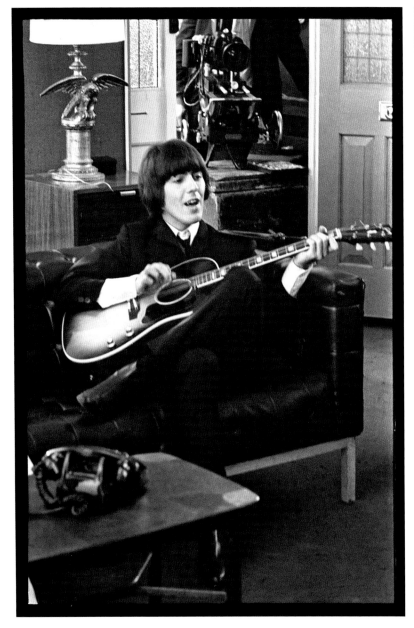
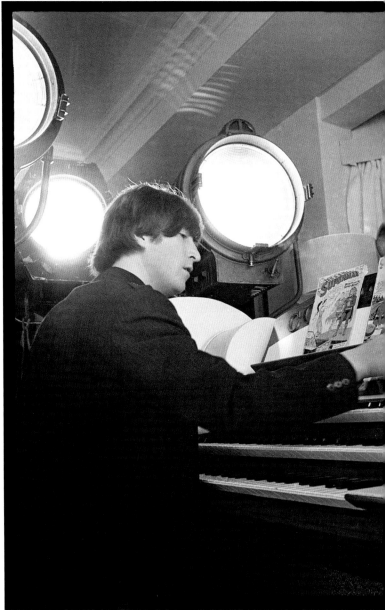

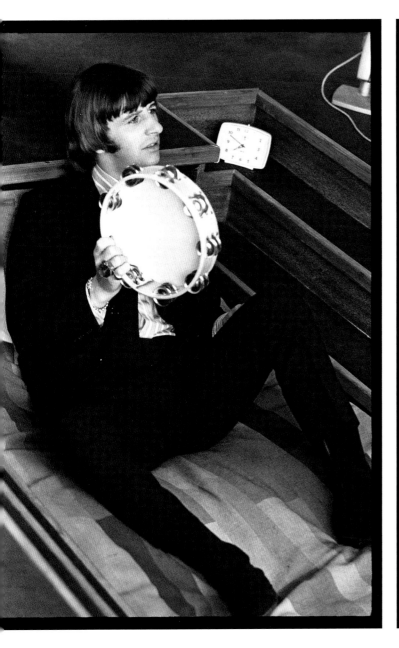
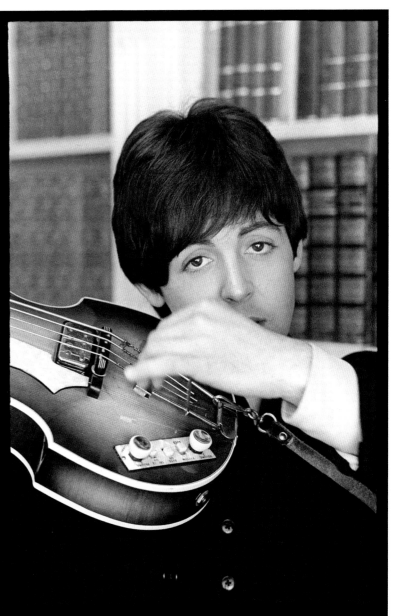

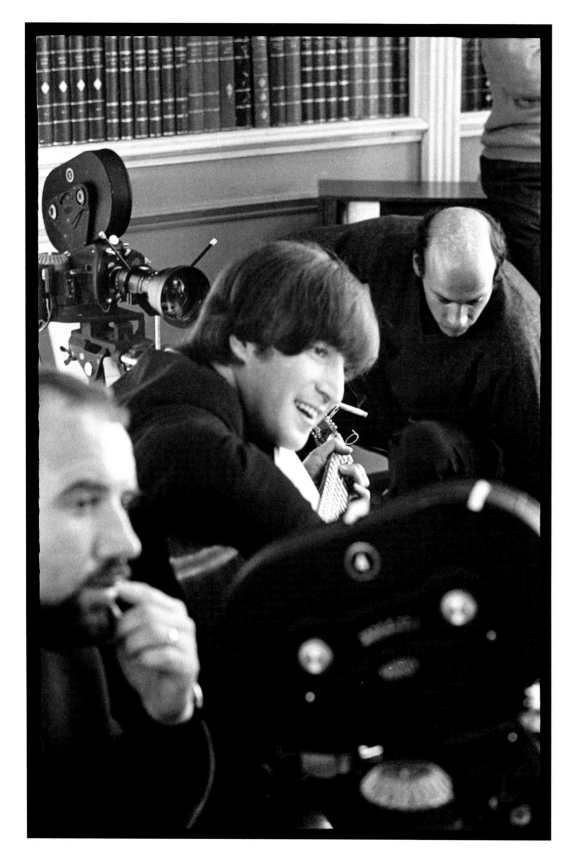

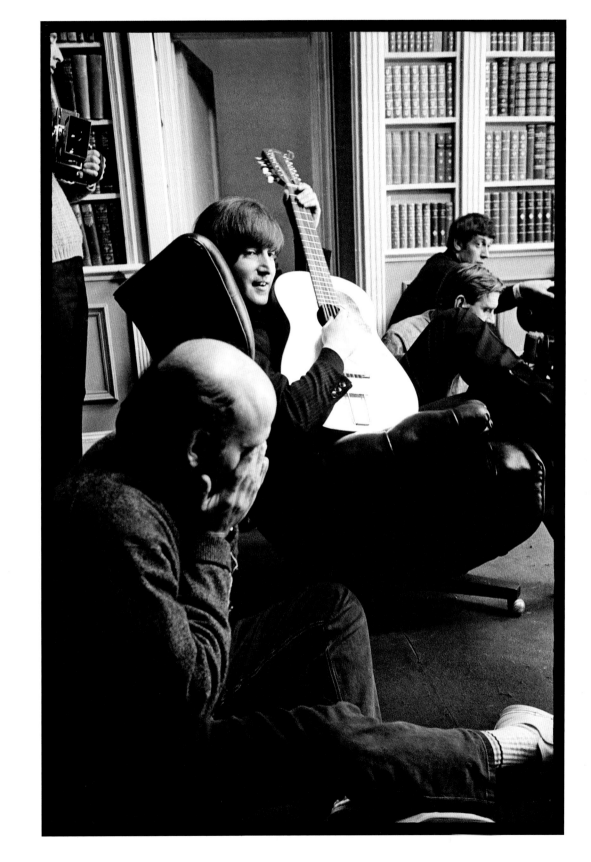

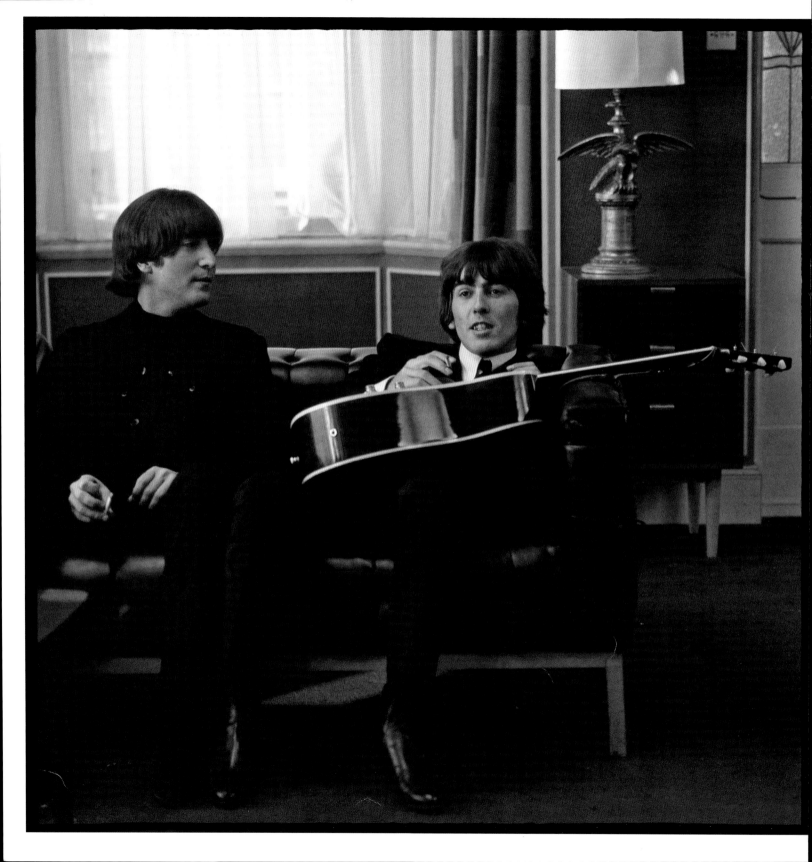

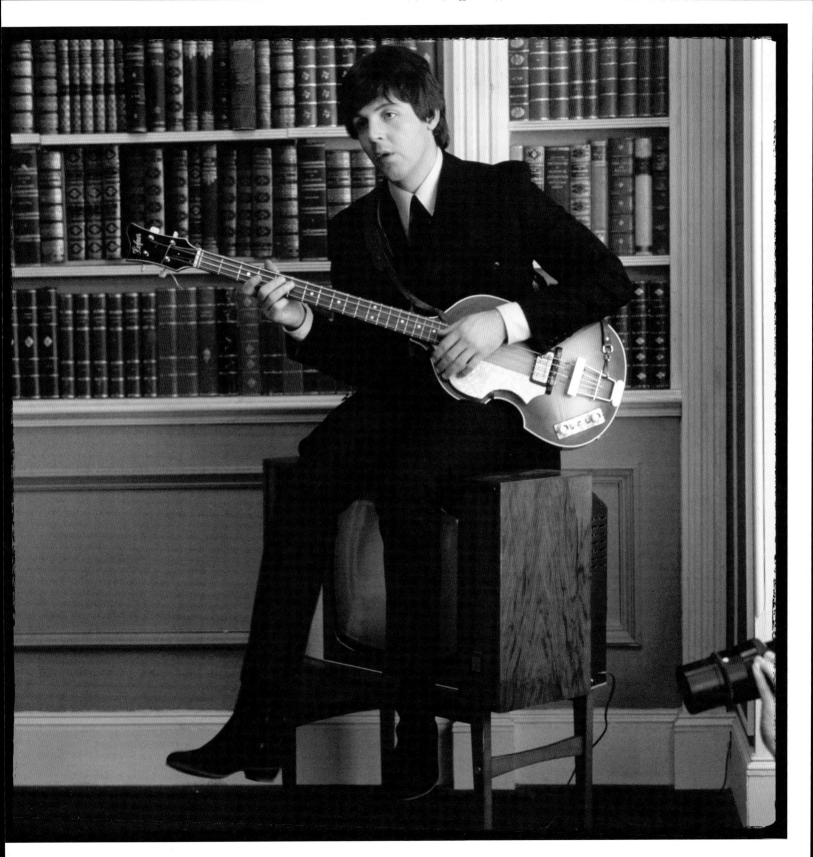

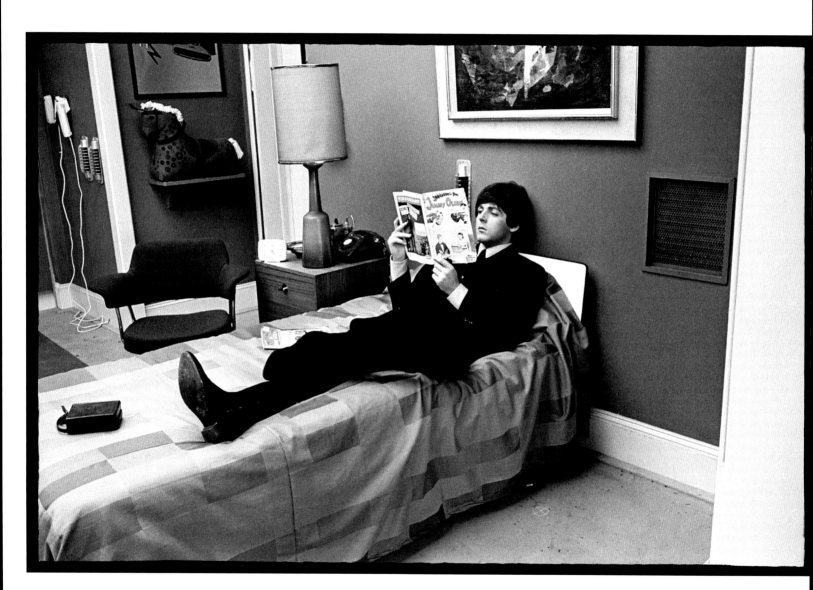

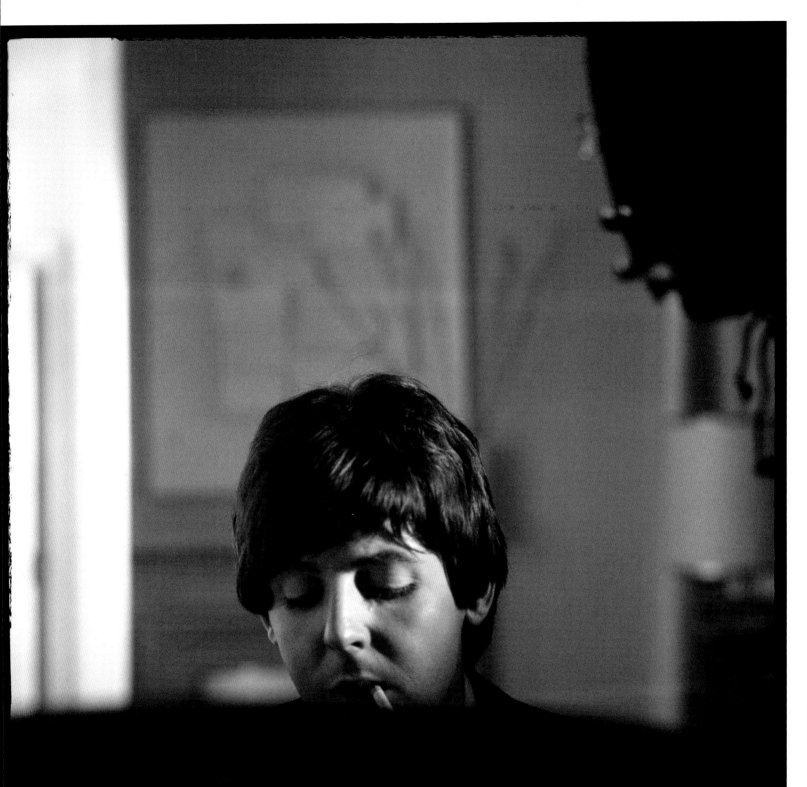

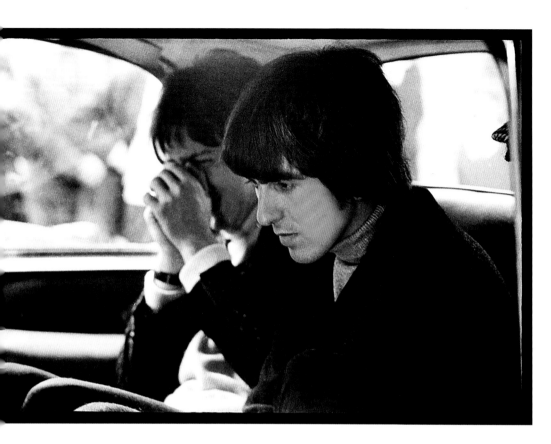
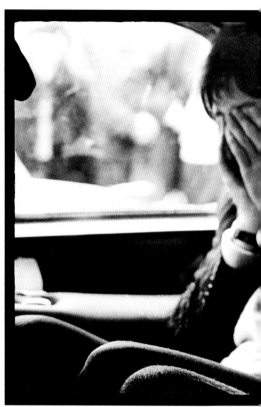
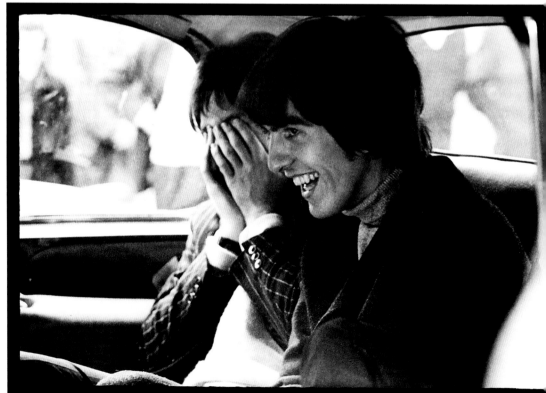

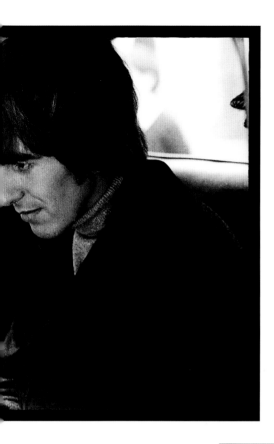
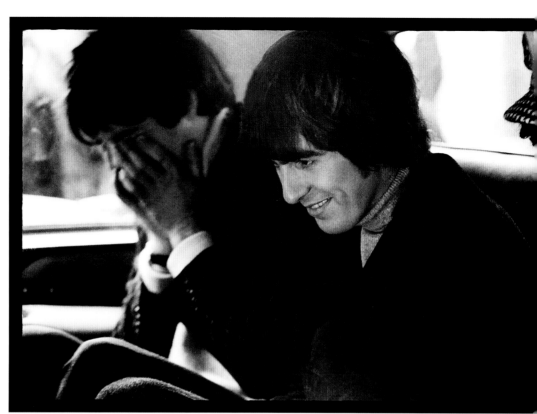
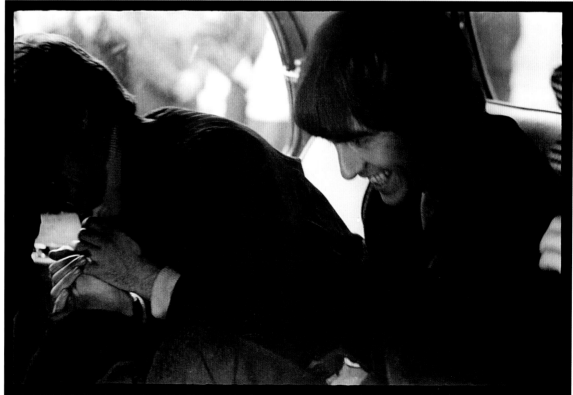

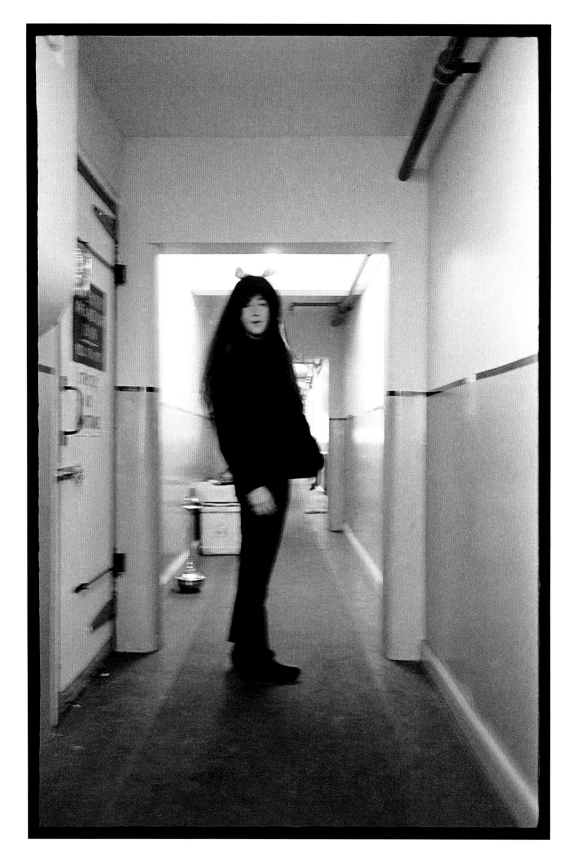

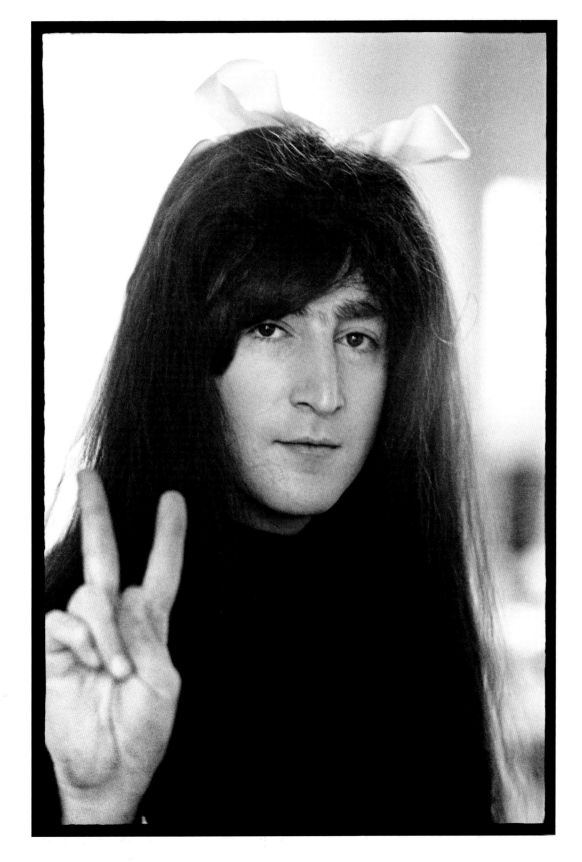

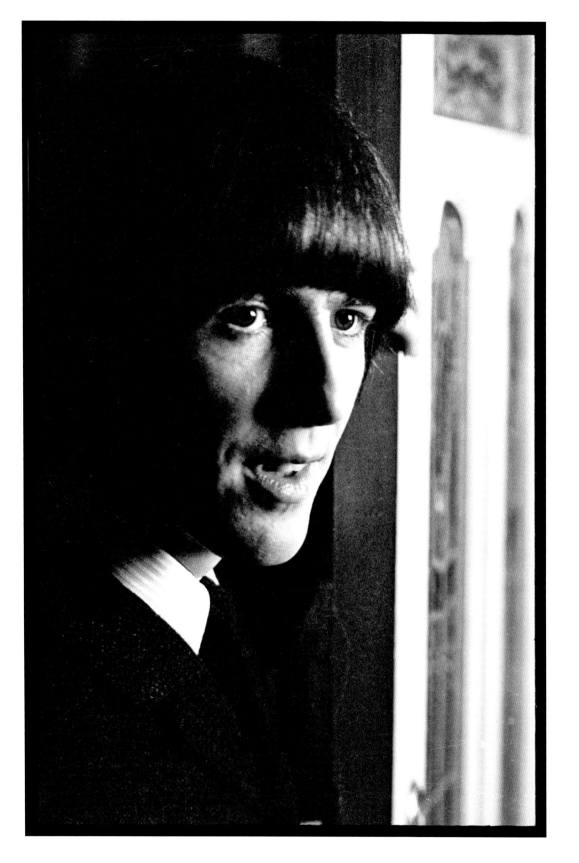

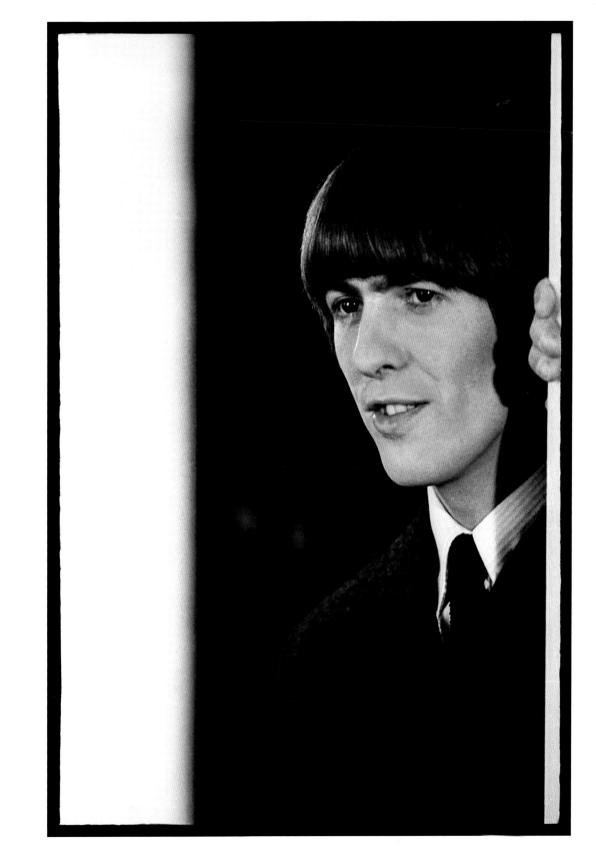

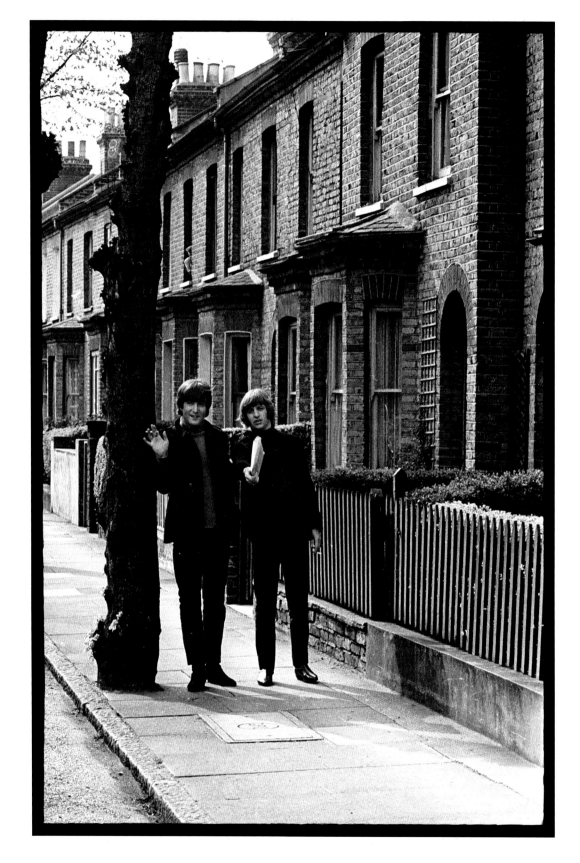

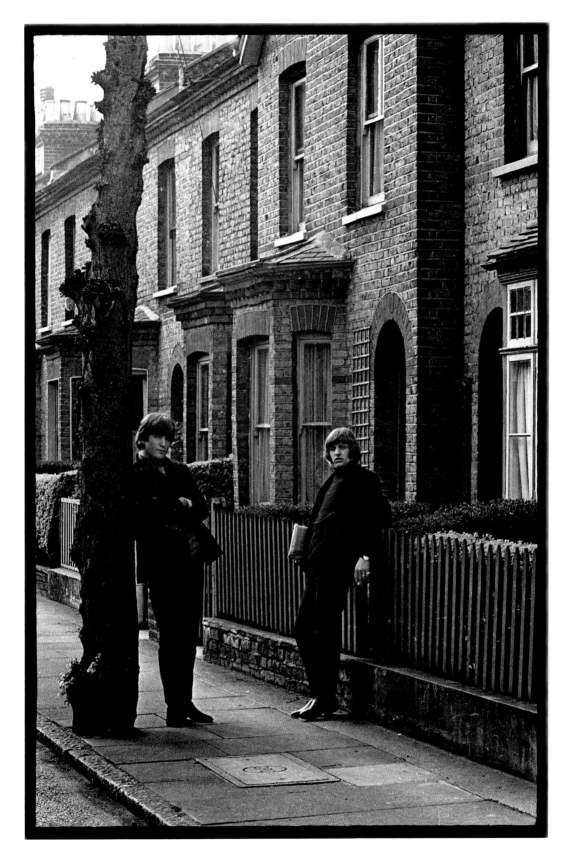

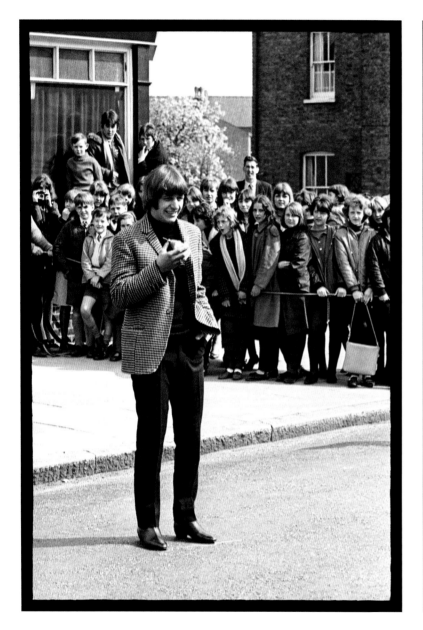

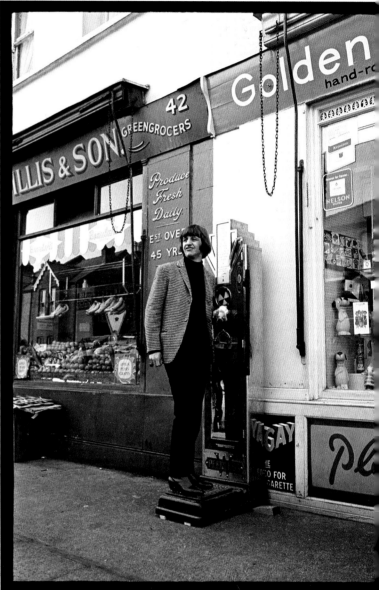

Ringo eats a pear while getting ready for a scene in the movie's famous "ring sequence." He stands on the scales of a weight machine and when he reaches for the card that drops out of the metal slot, a miniature guillotine almost chops his finger off.

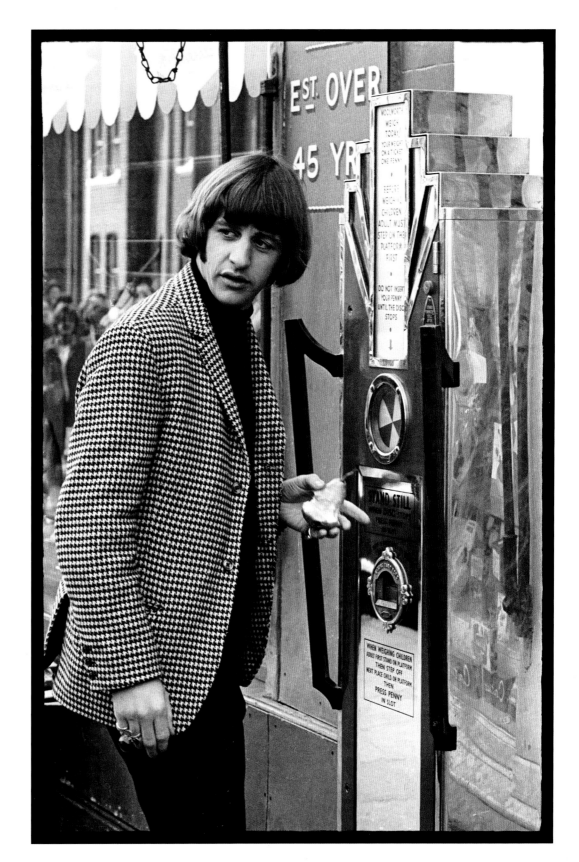

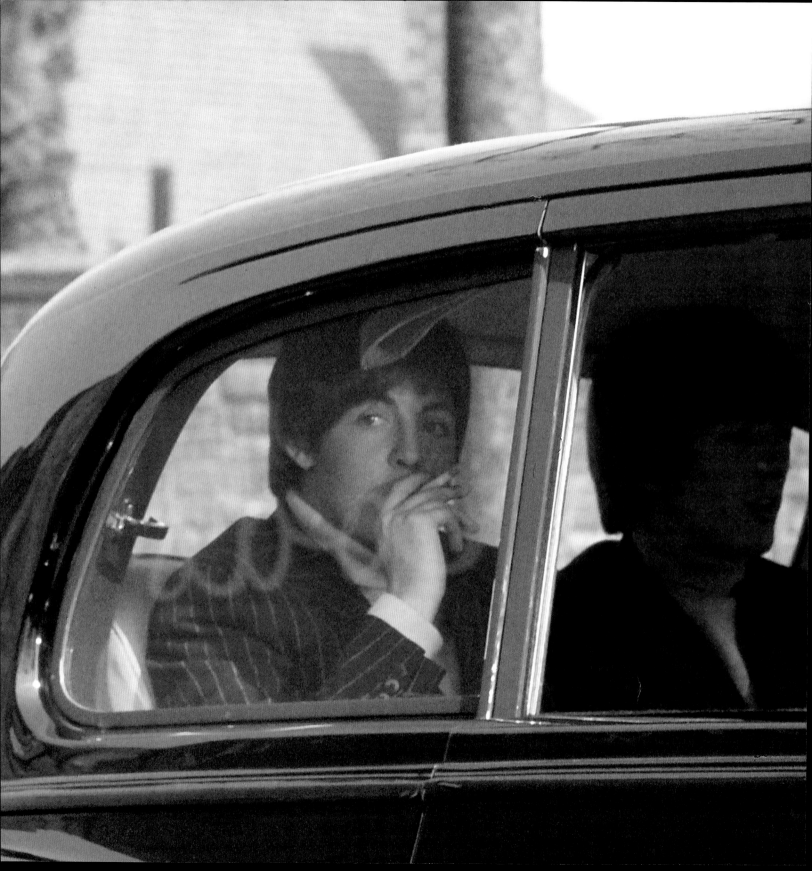

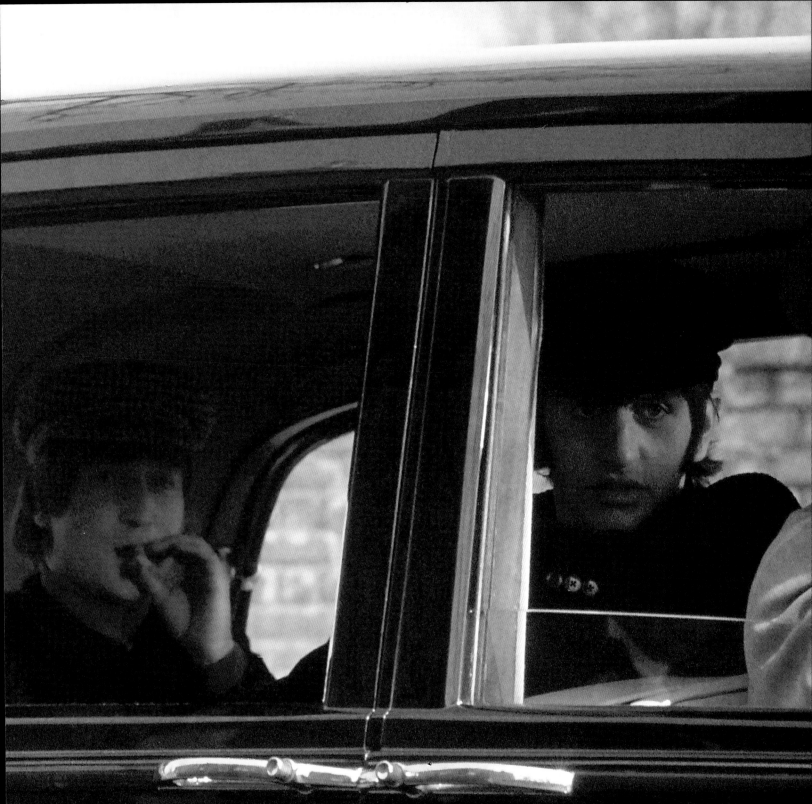

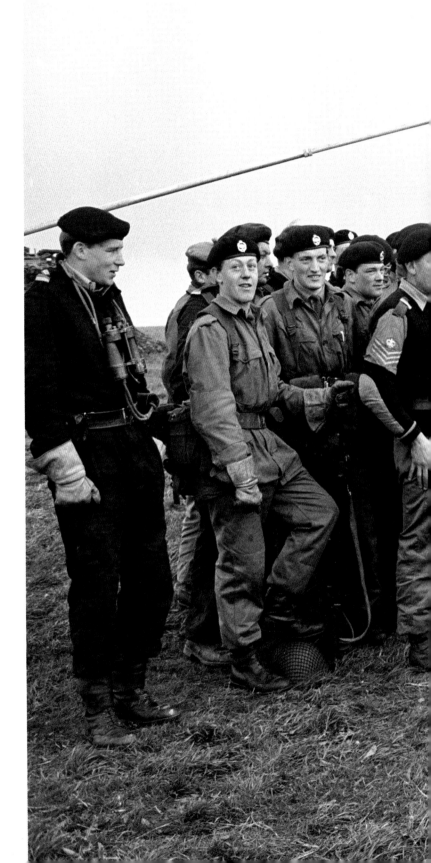

"The army loved it," said Richard Lester, who managed to convince the Third Division of the Royal Artillery to work as extras in a series of outdoor sequences that were shot on Salisbury Plain, not far from the ancient site of Stonehenge. More than fifty soldiers and seven Centurion tanks participated in the film.

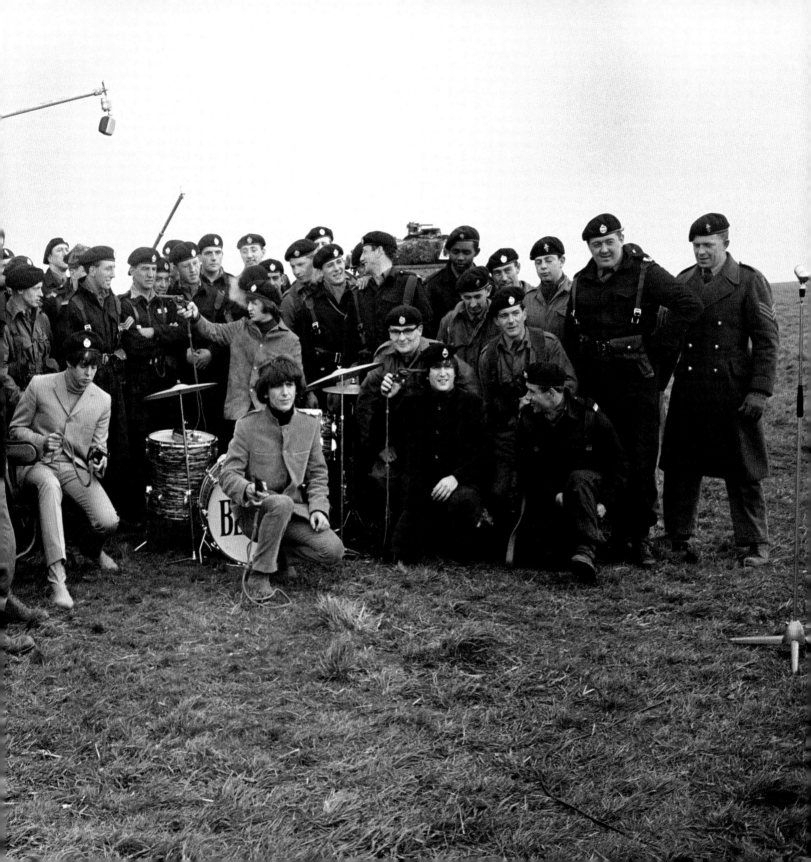

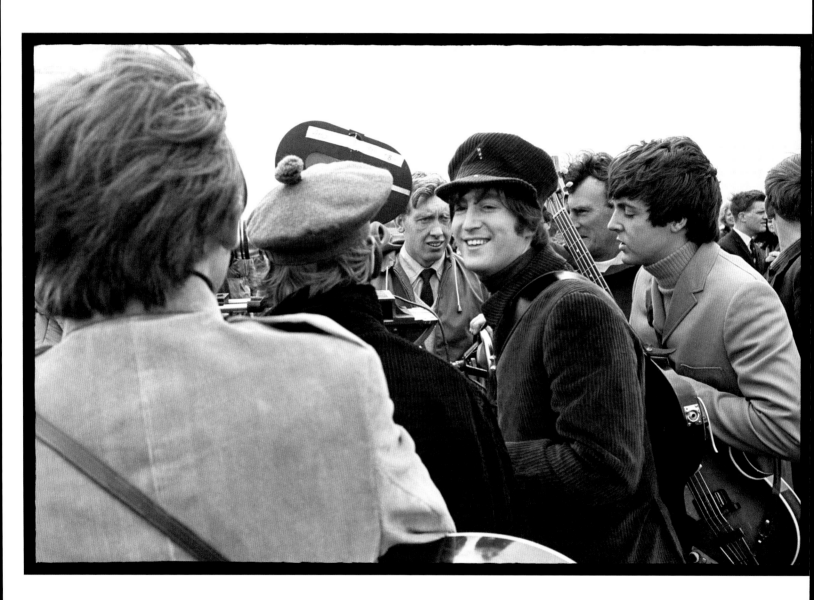

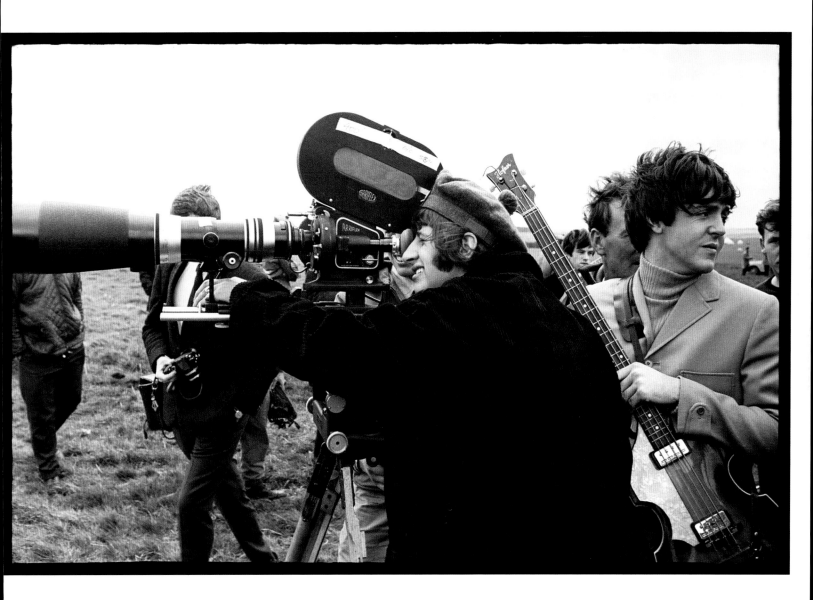

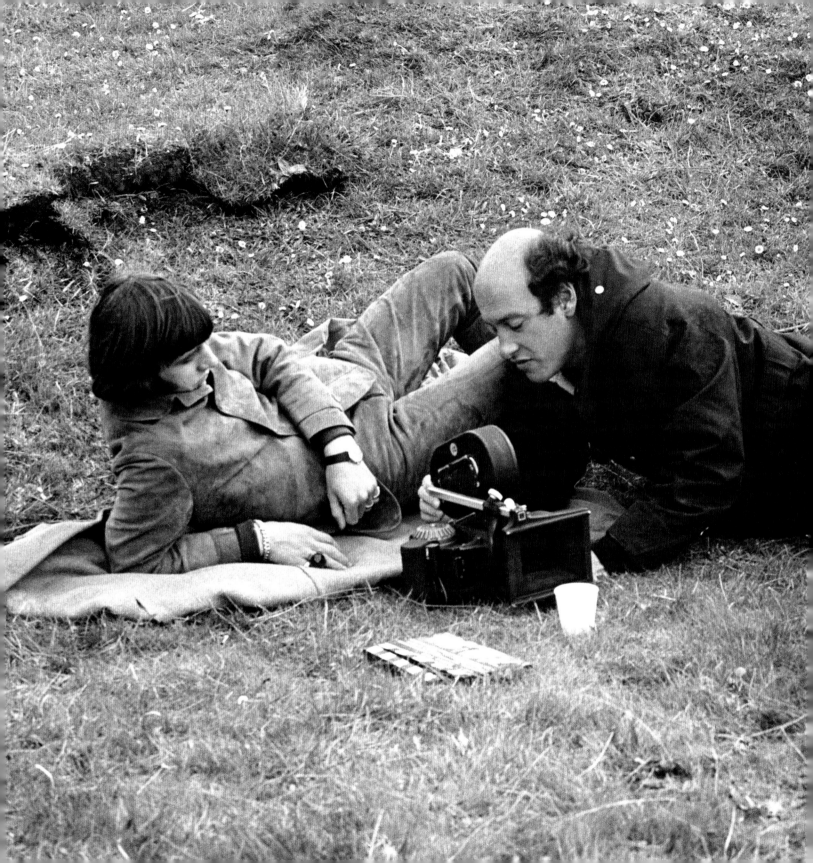

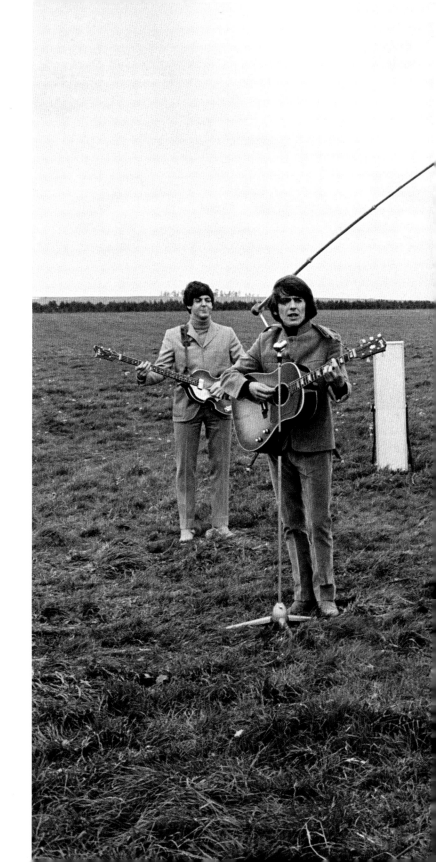

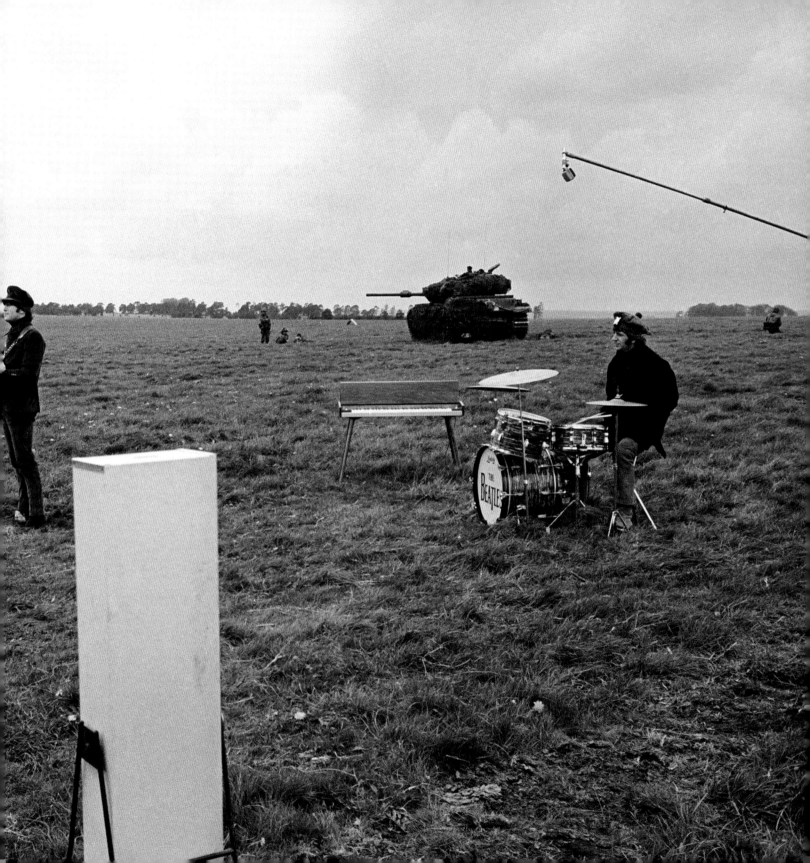

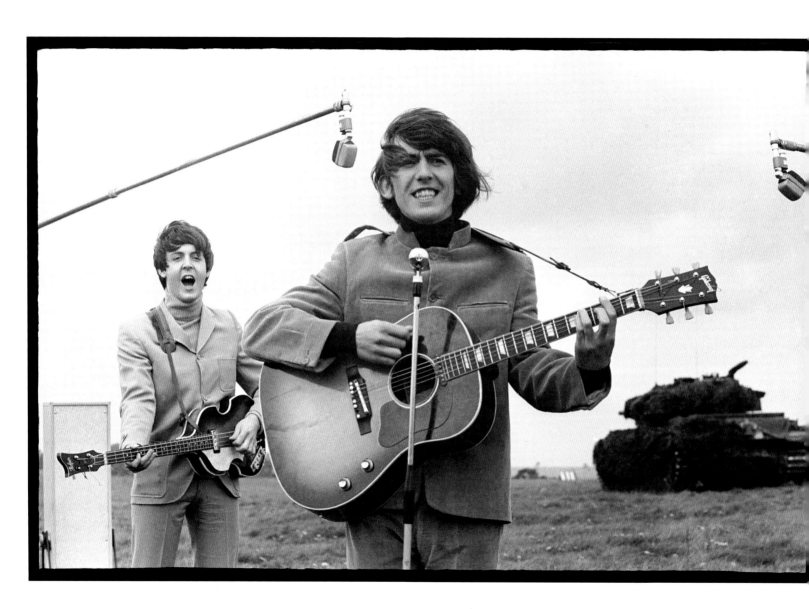

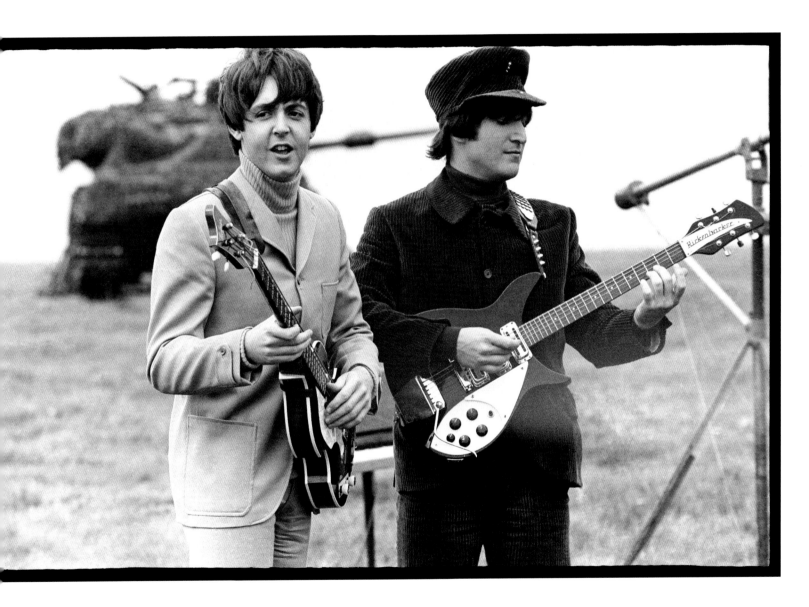

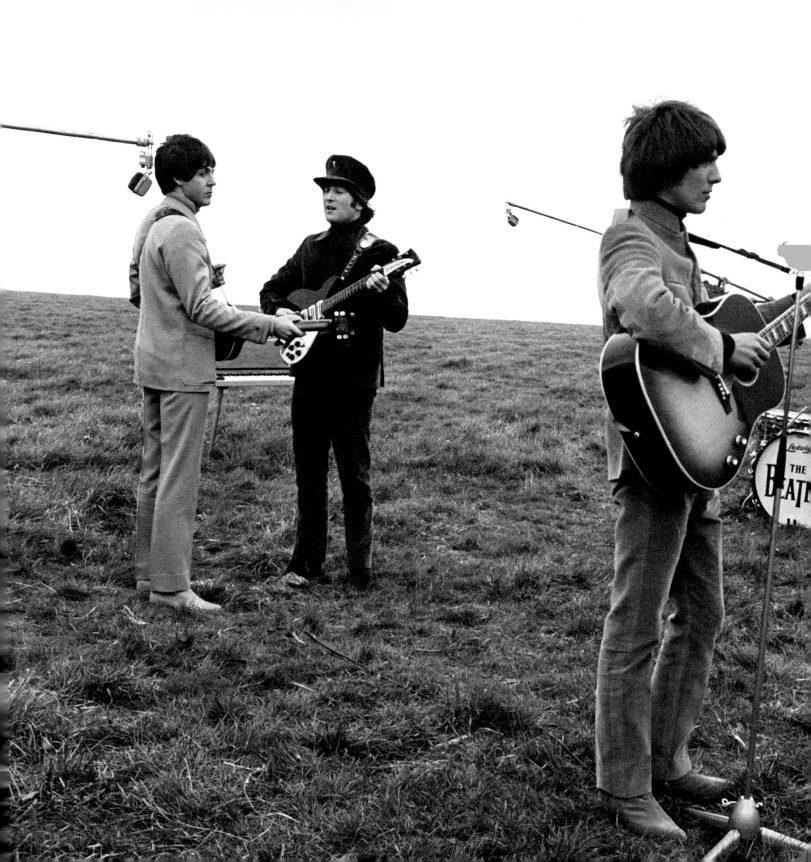

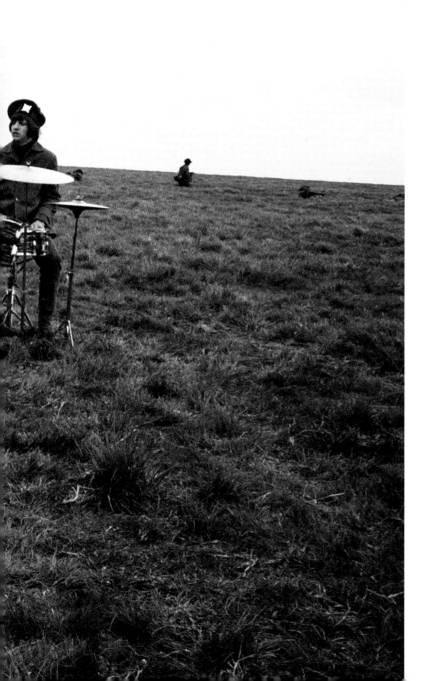

George plays his guitar on Salisbury Plain. It said something about the Beatles' status as international celebrities that even the British army agreed to accommodate their needs and serve as background extras in *Help!* The soldiers were just as much fans—taking photographs, asking for autographs—as the screaming schoolgirls in London.

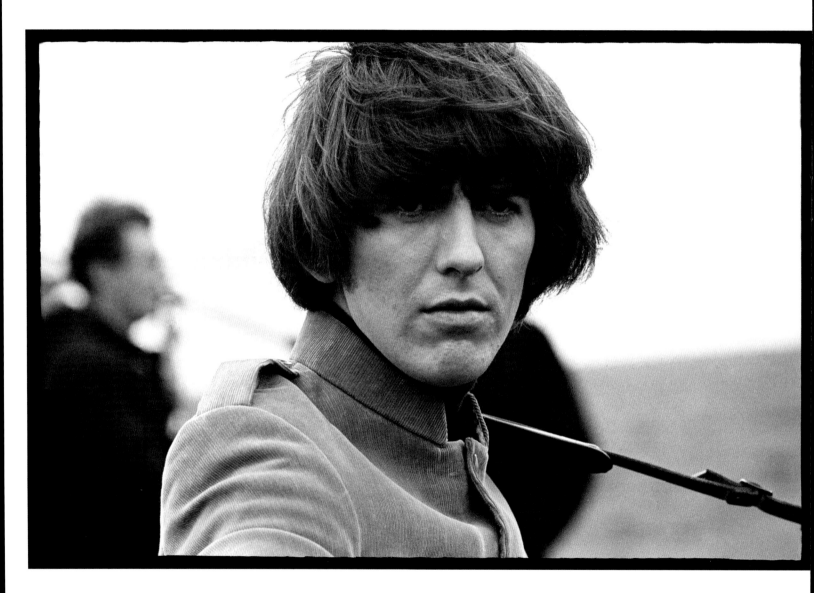

86

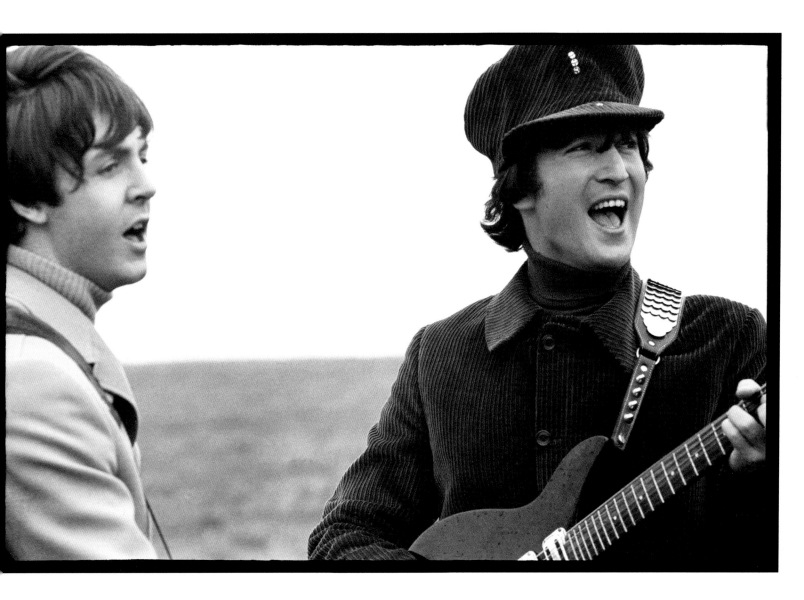

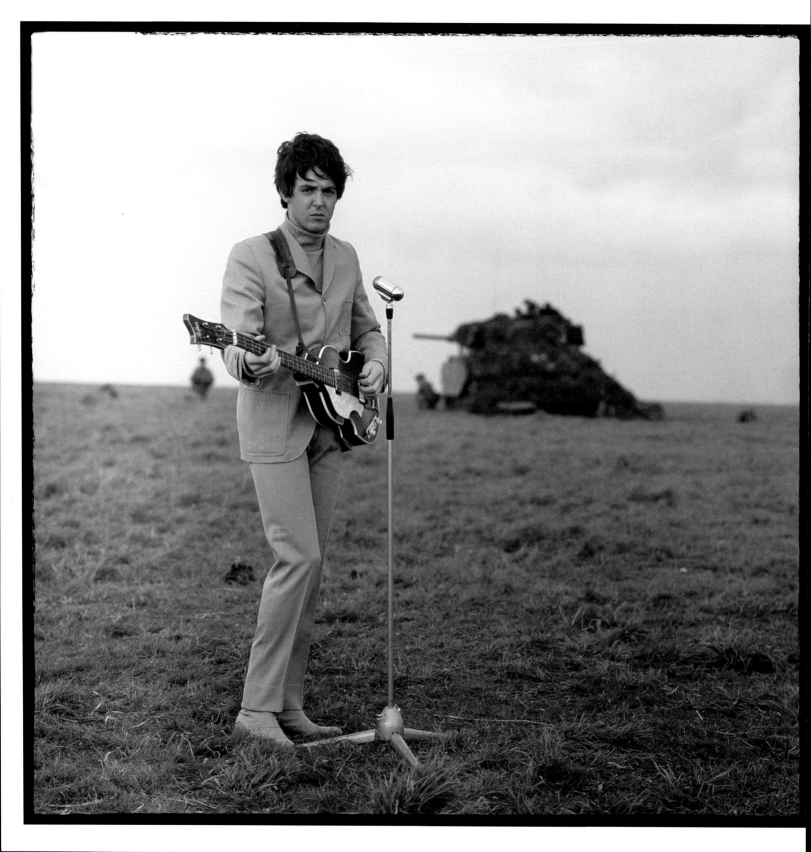

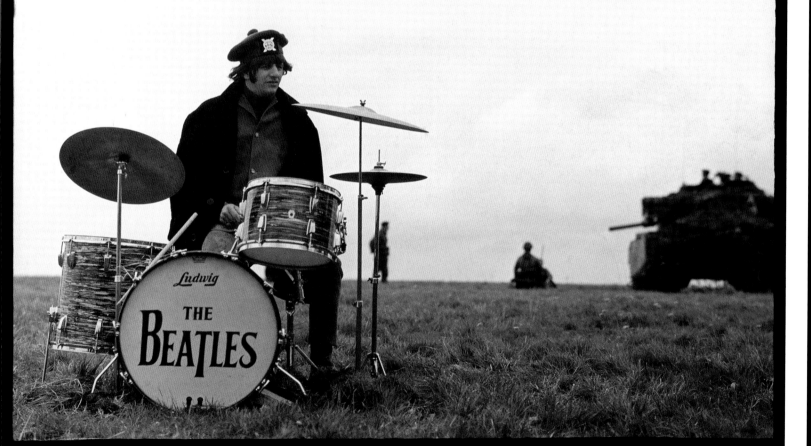

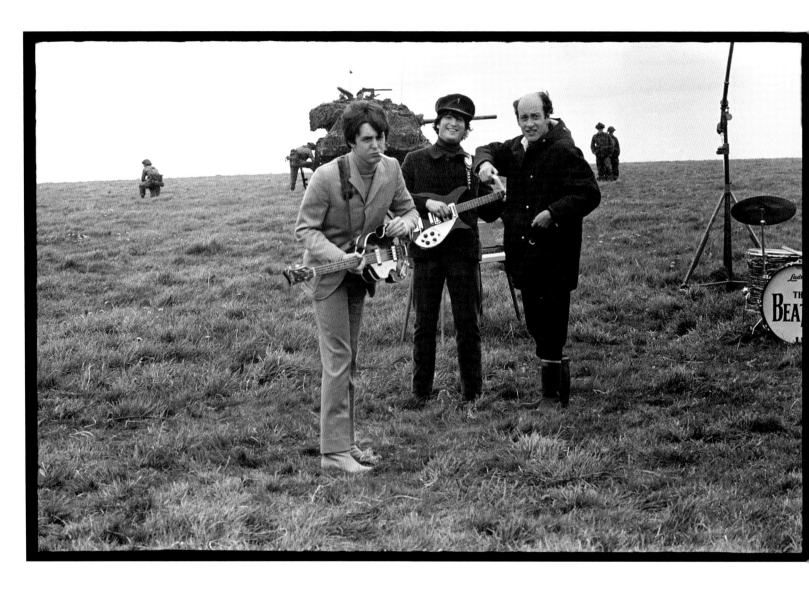

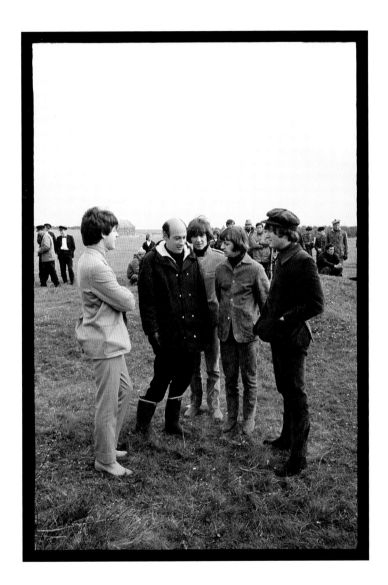

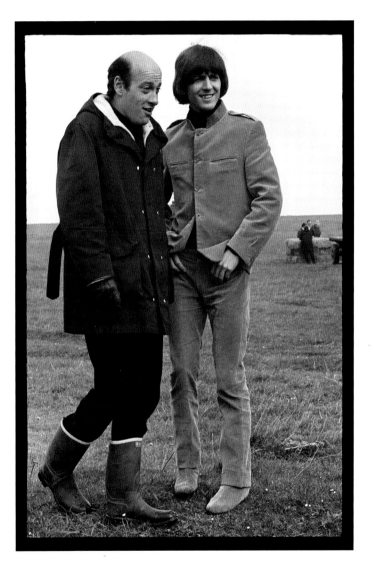

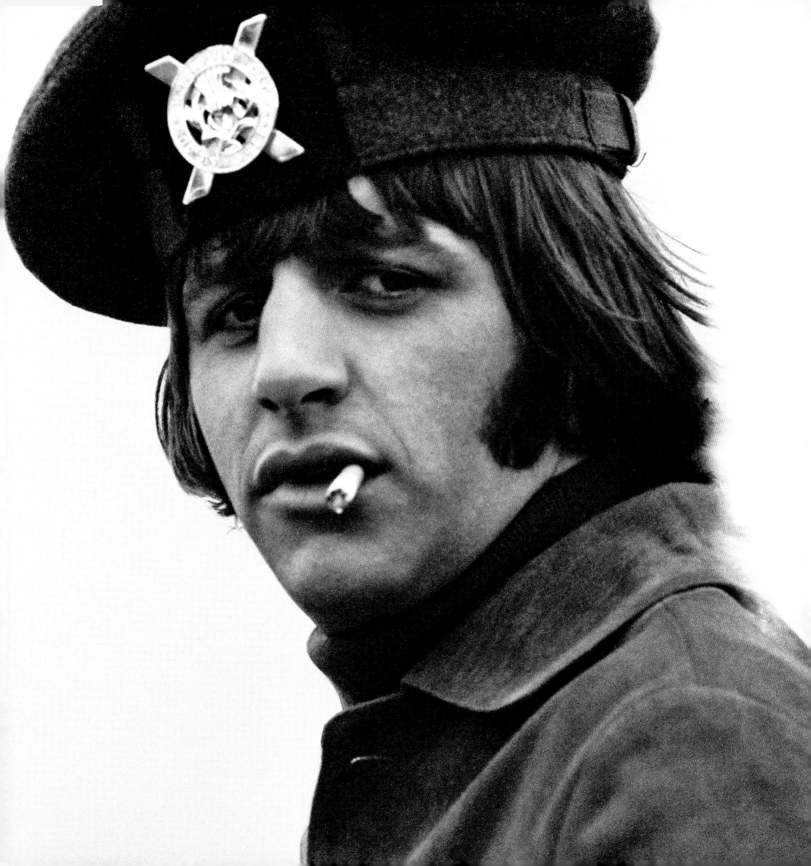

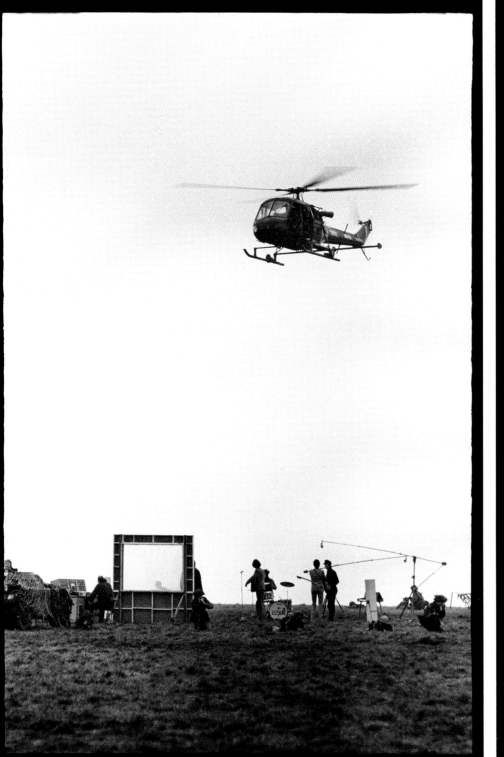
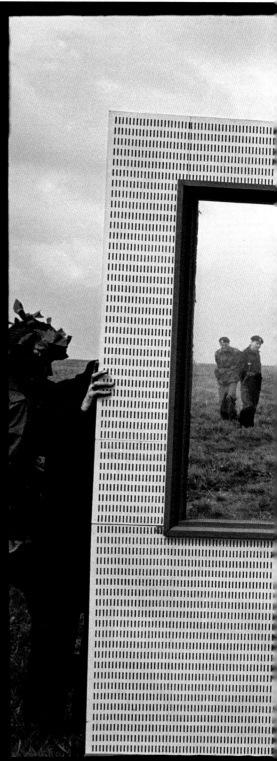

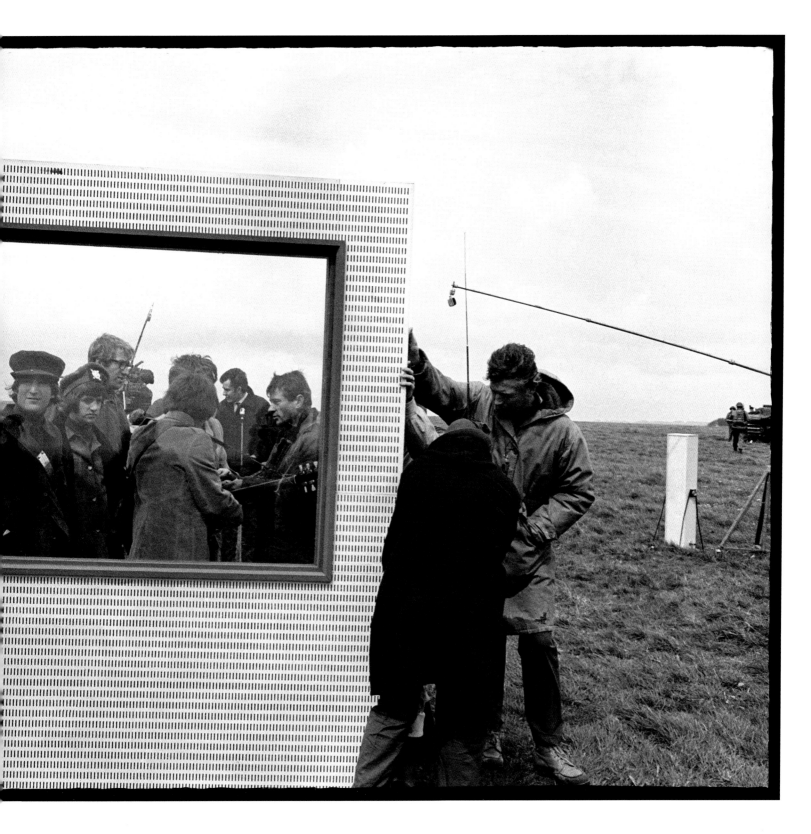

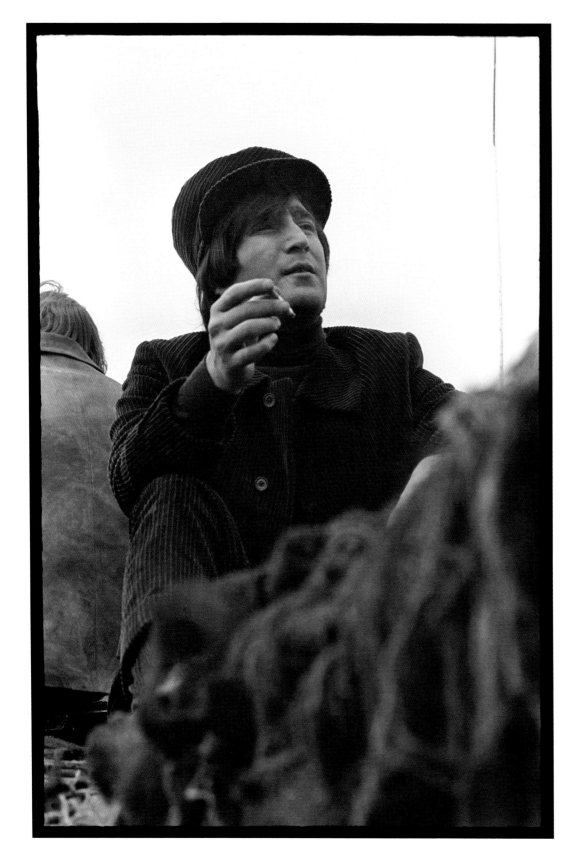

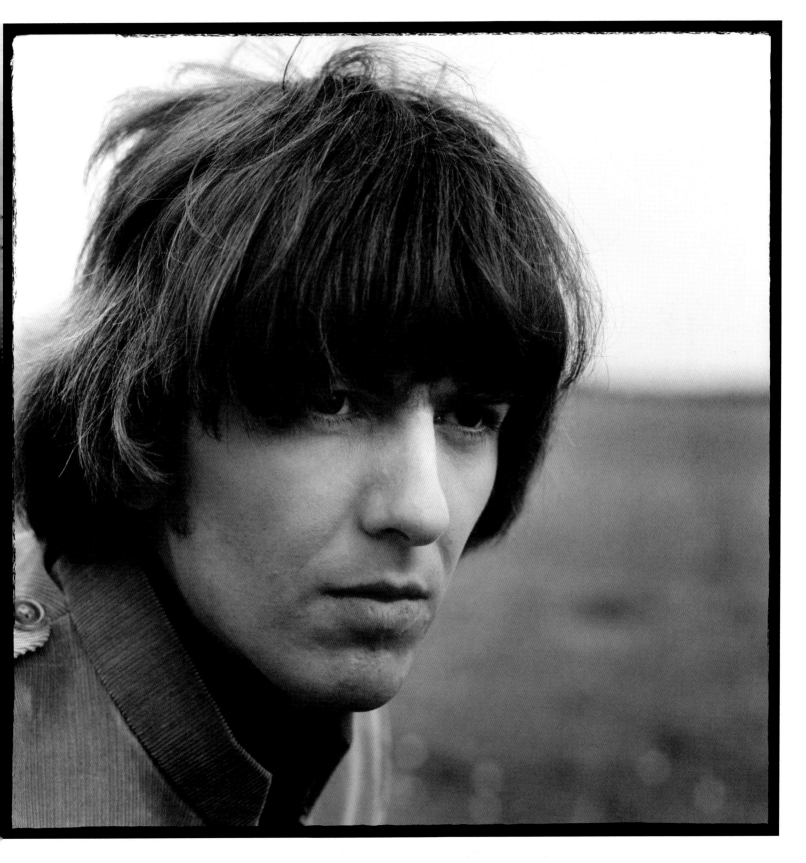

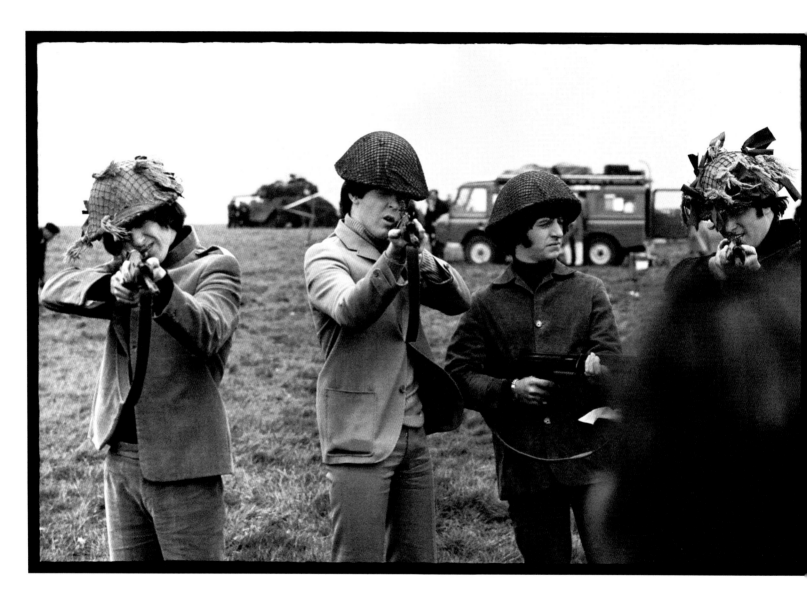

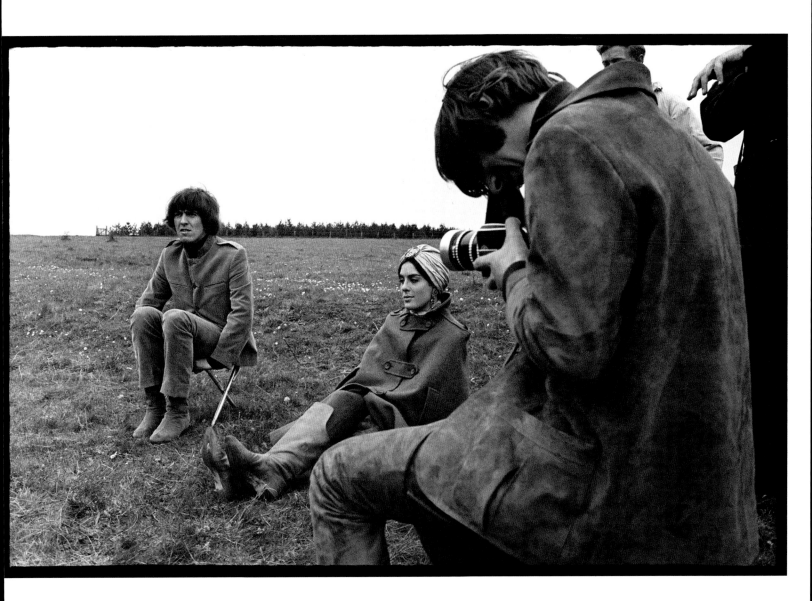

99

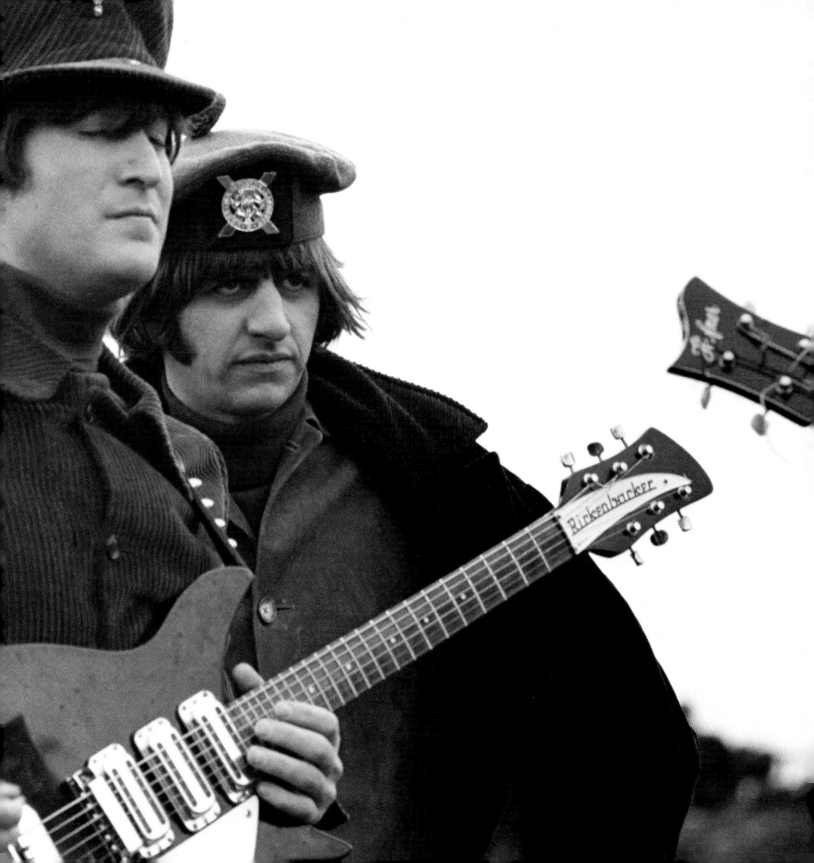

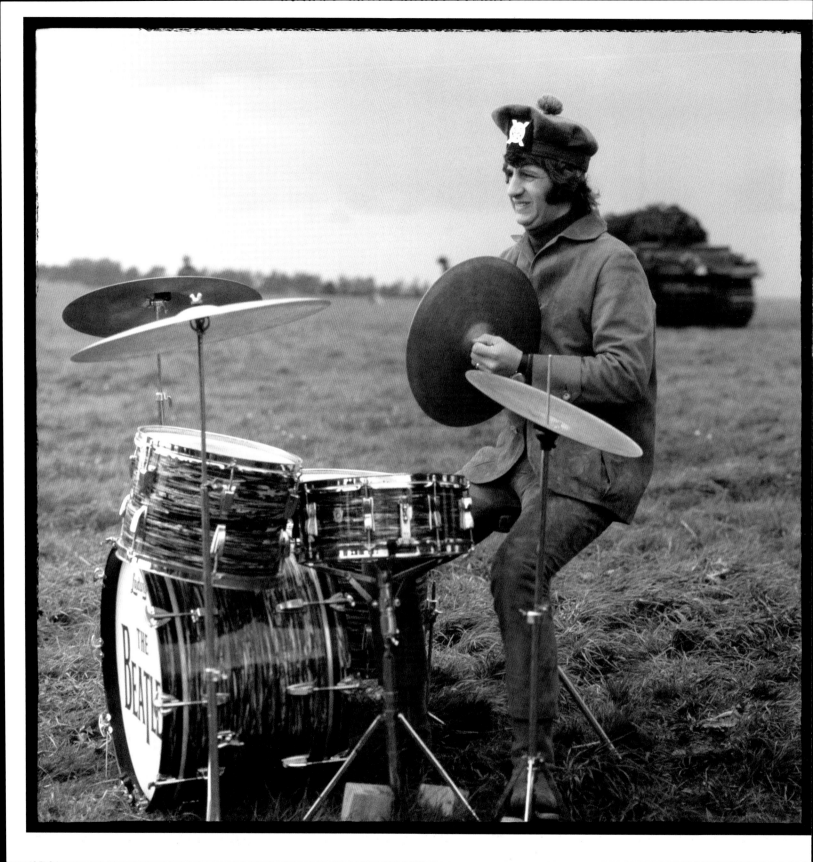

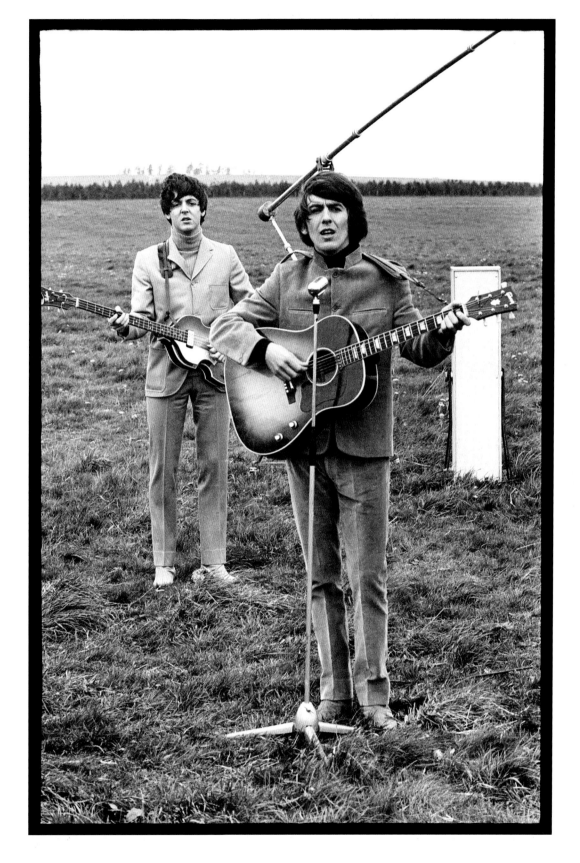

Lari took thousands of pictures on the set of *Help!* from every conceivable vantage point, getting as close to the action as he could, working his way behind the cameraman, positioning himself between Richard Lester and the assistant director, crawling on the floor for a better angle.

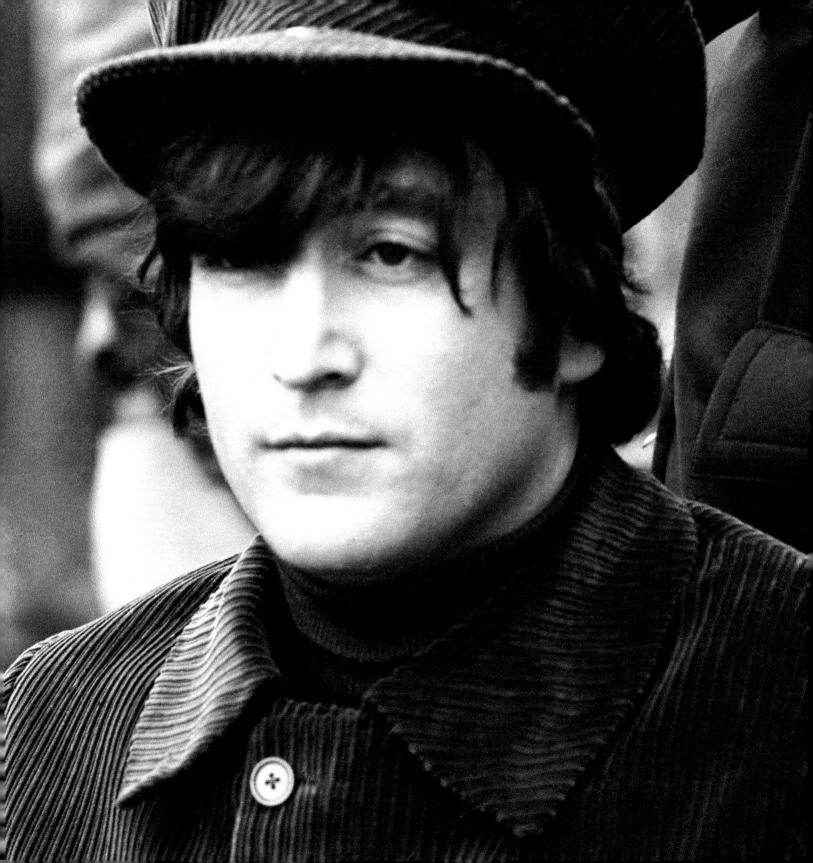

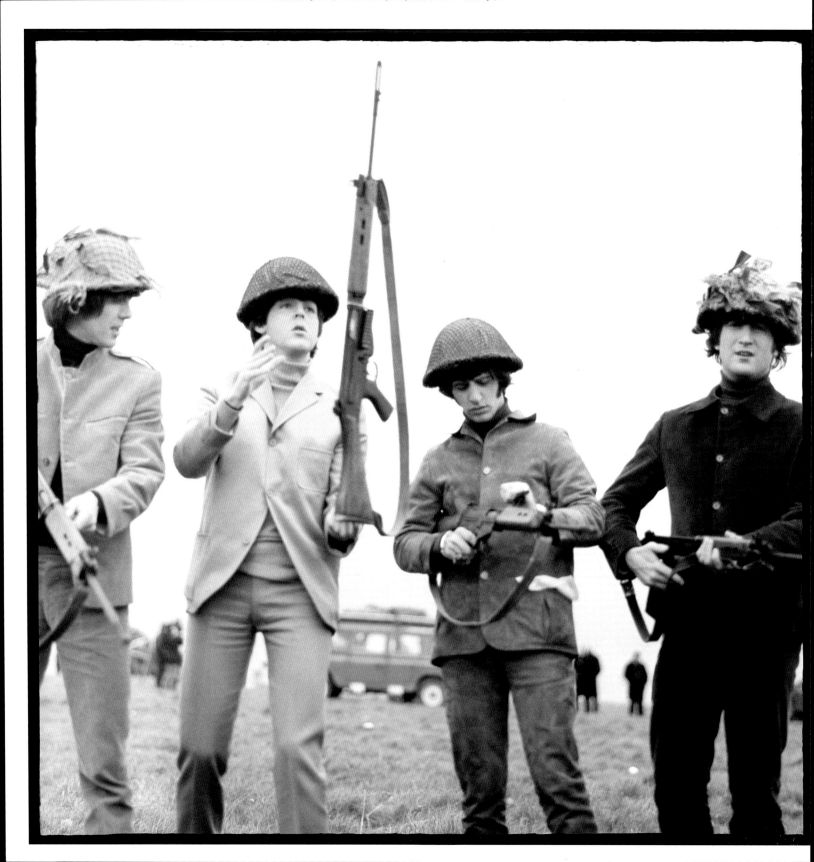

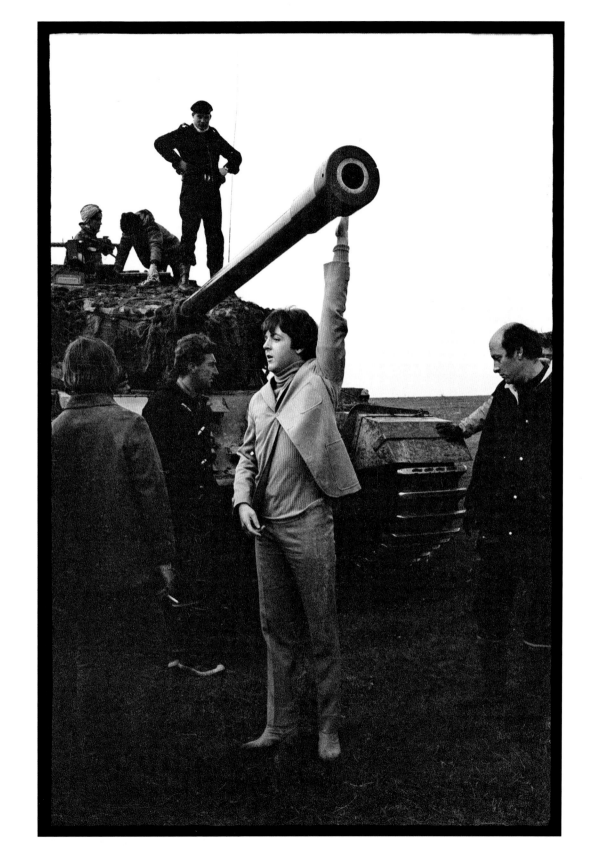

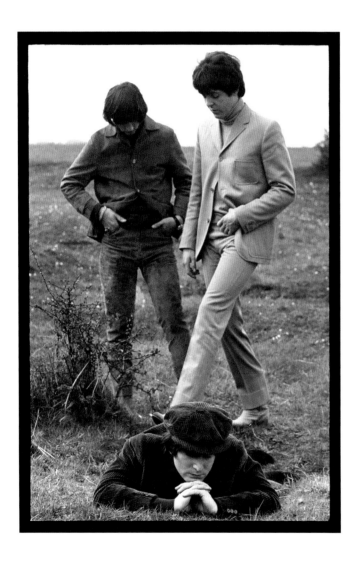

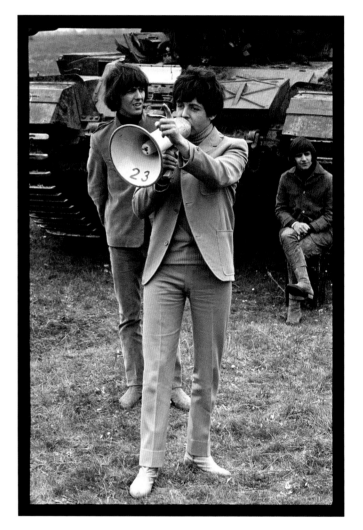

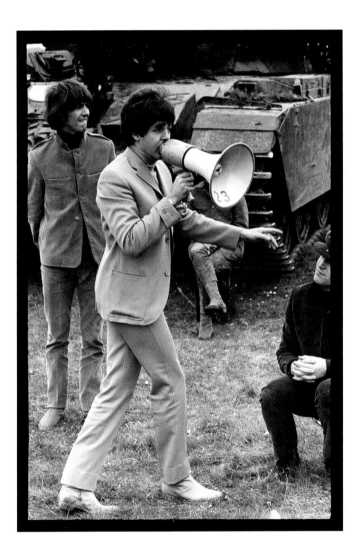

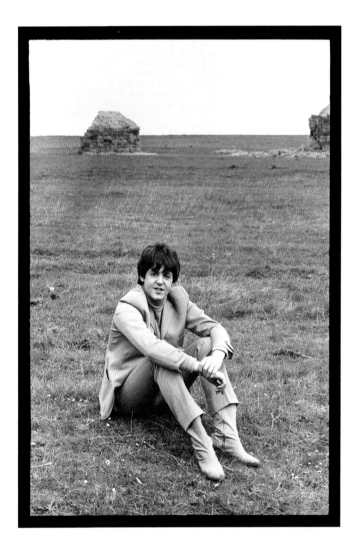

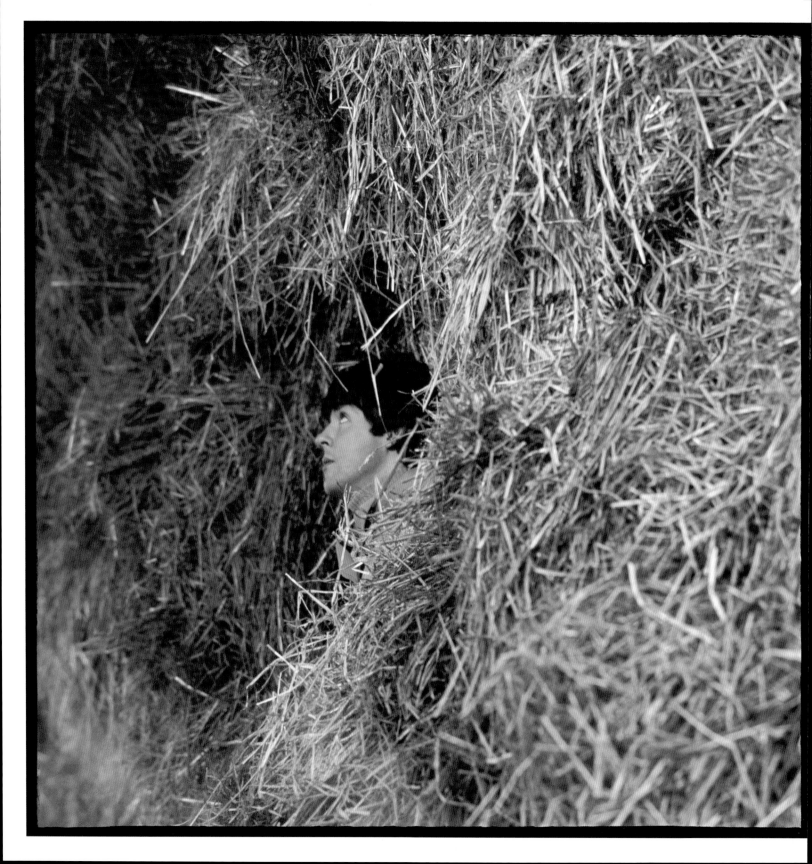

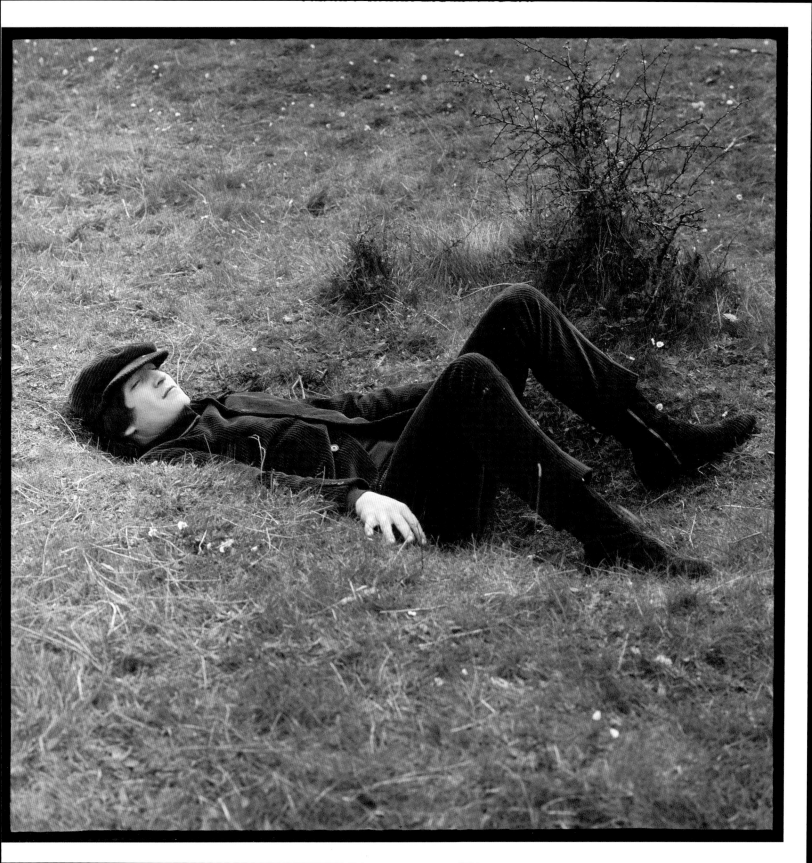

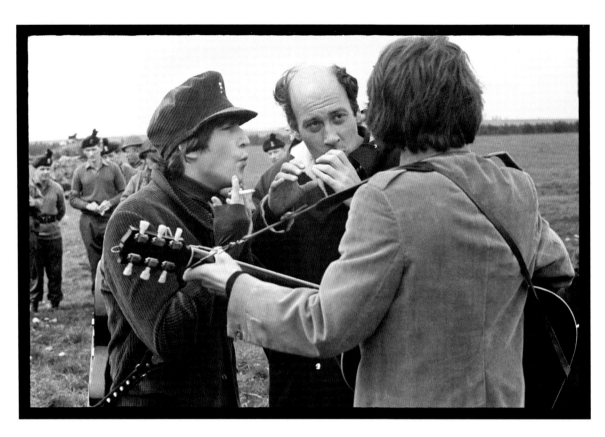

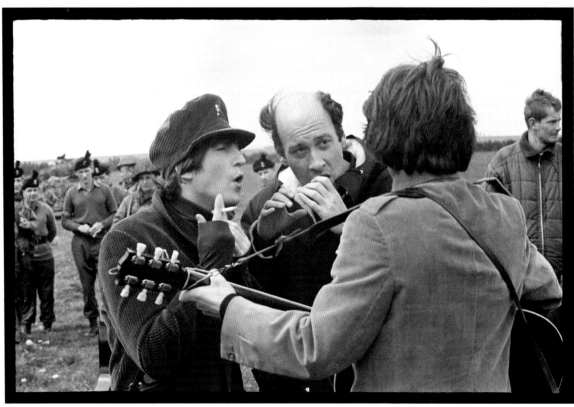

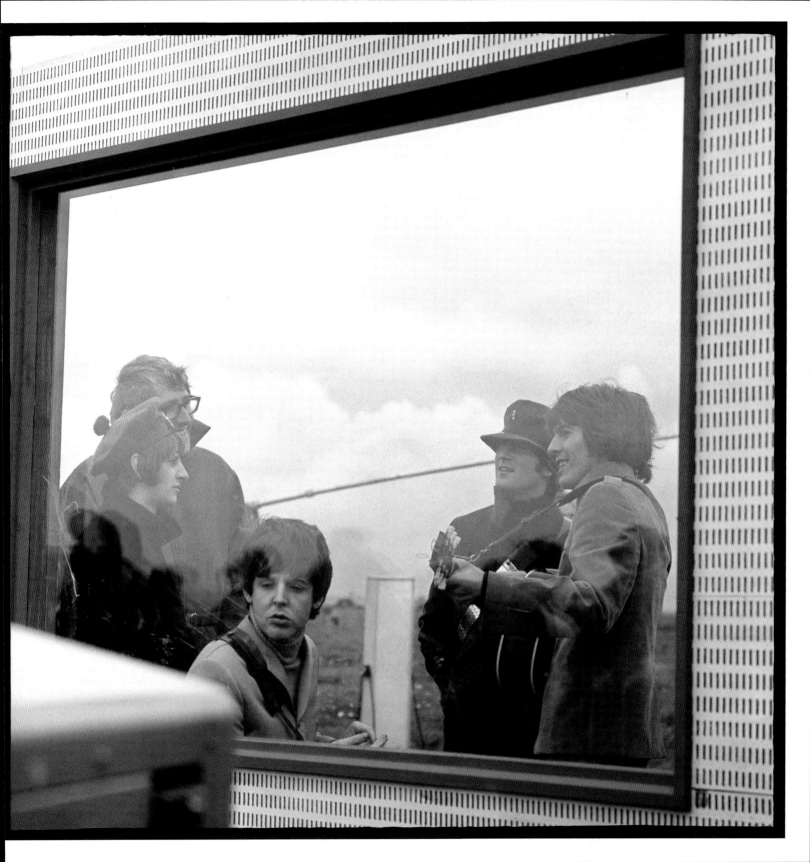

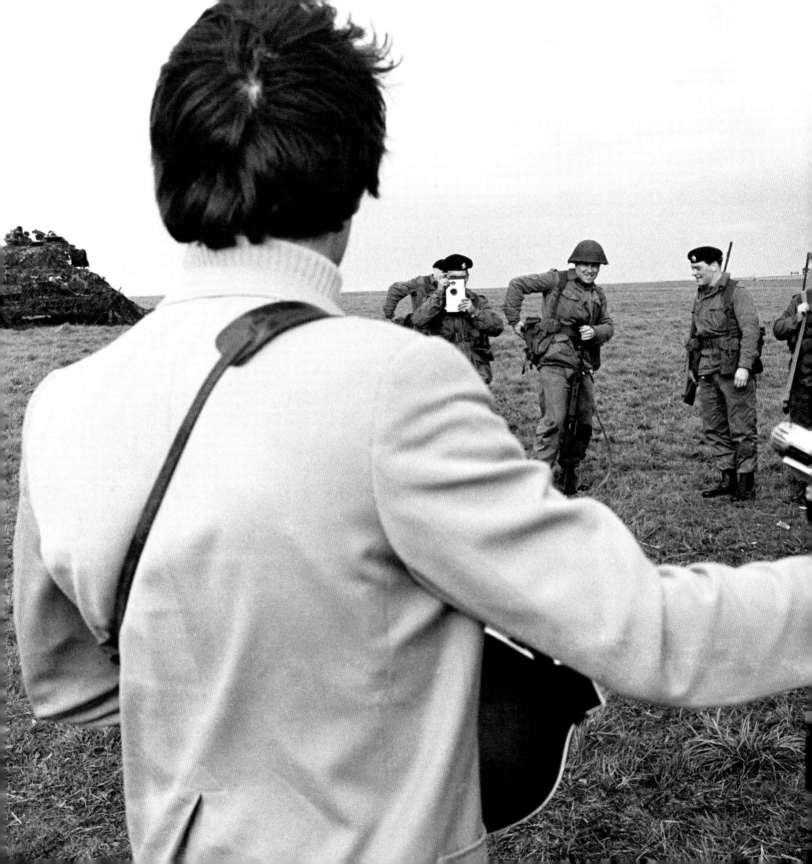

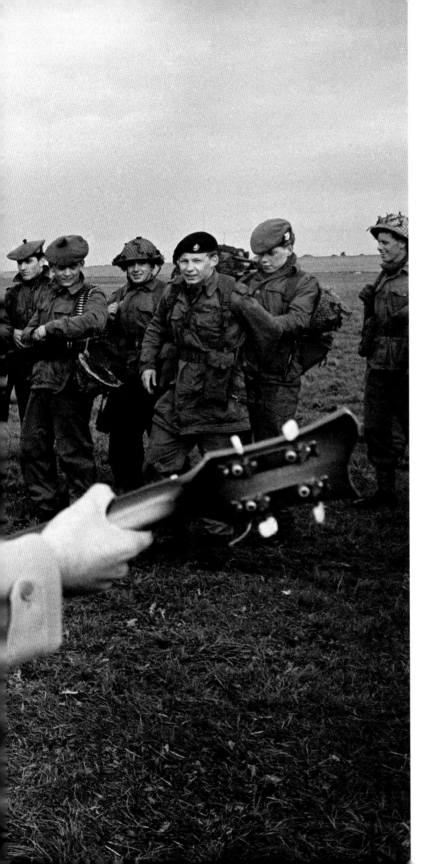

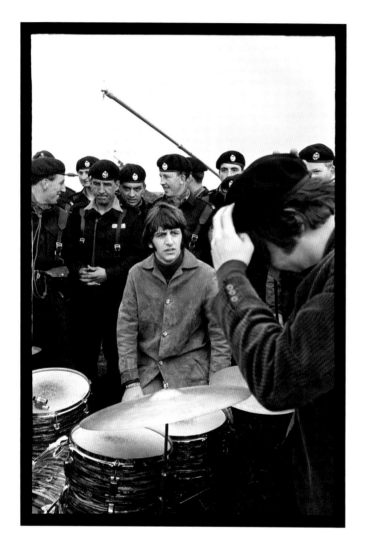

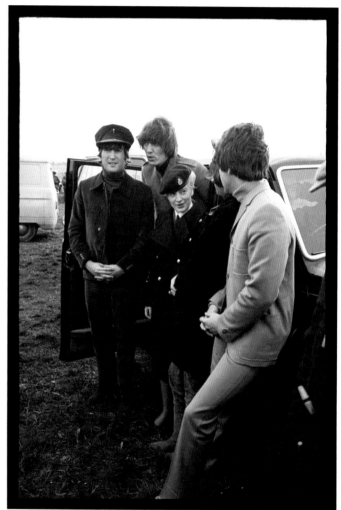

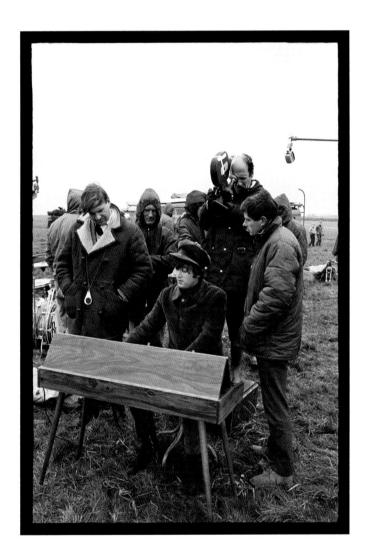
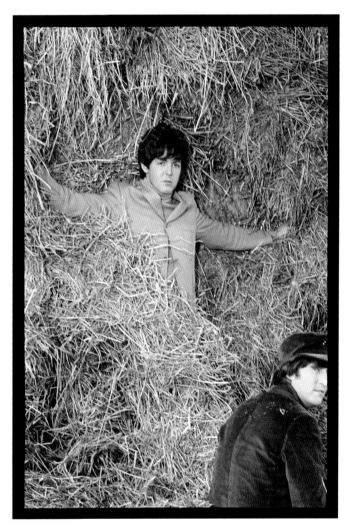

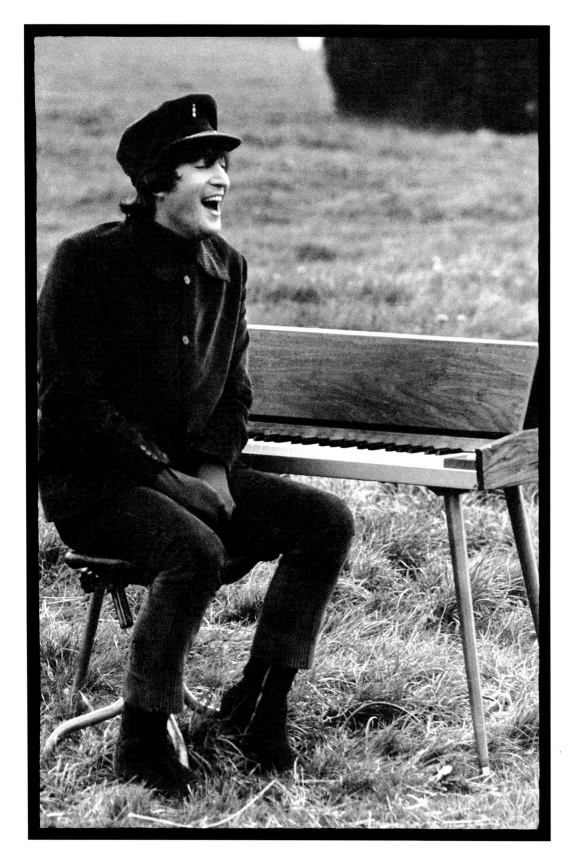

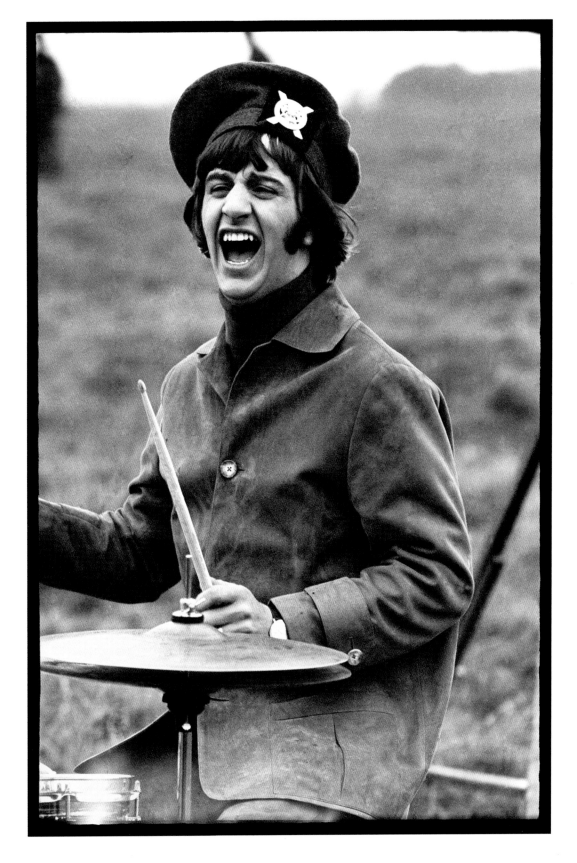

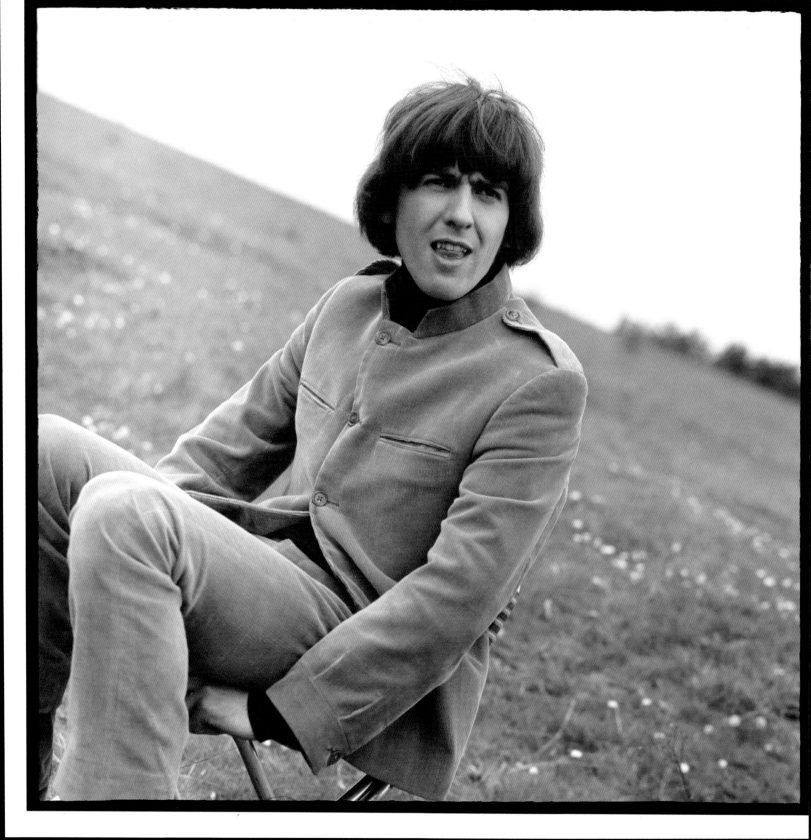

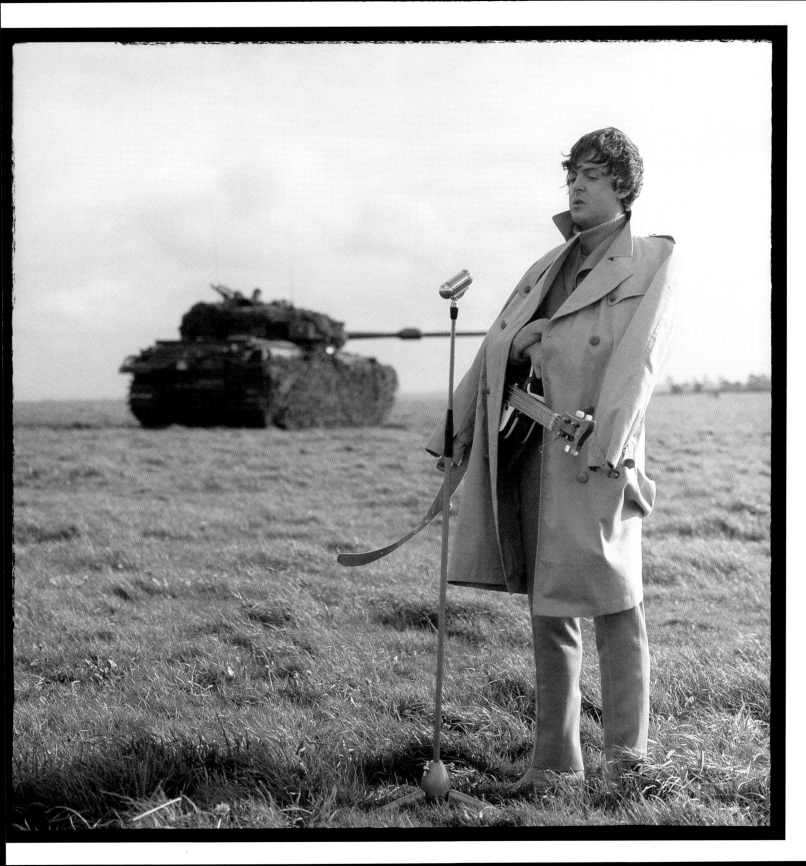

Despite the fact that it was already late spring, the weather was unusually chilly, and you can see Ringo shivering at his drum kit. "Those poor boys. No one was really looking after them," said Emilio Lari. "They didn't have a chair to sit on between takes so they just lay on the ground, shivering."

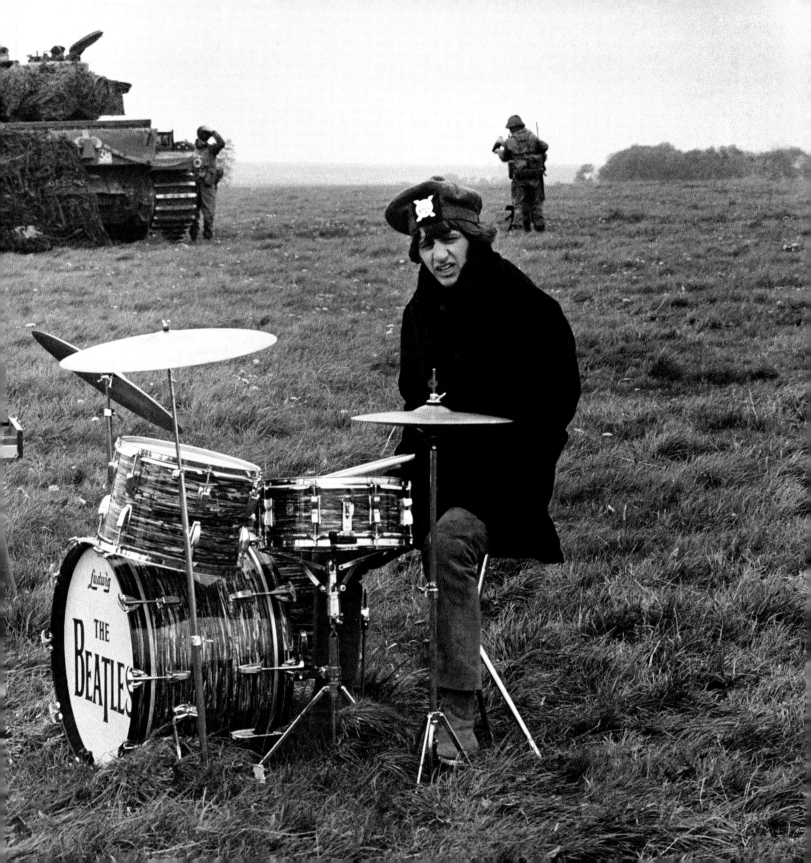

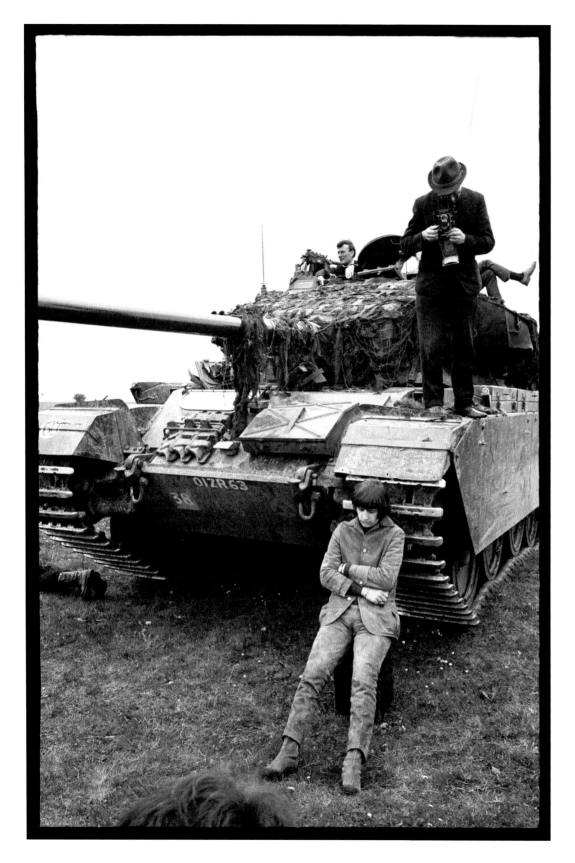

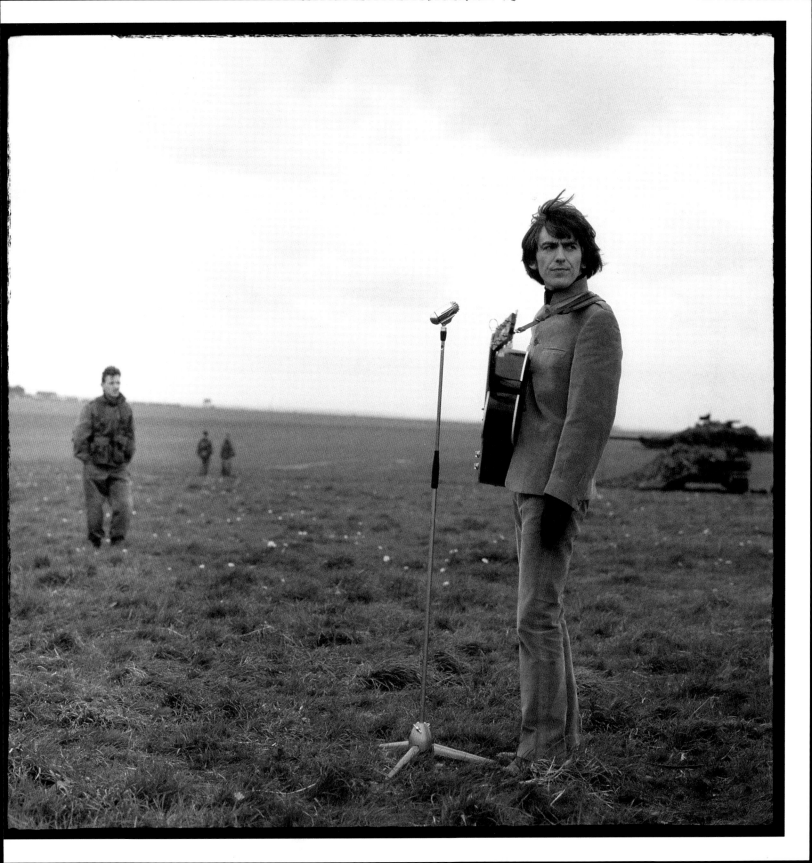

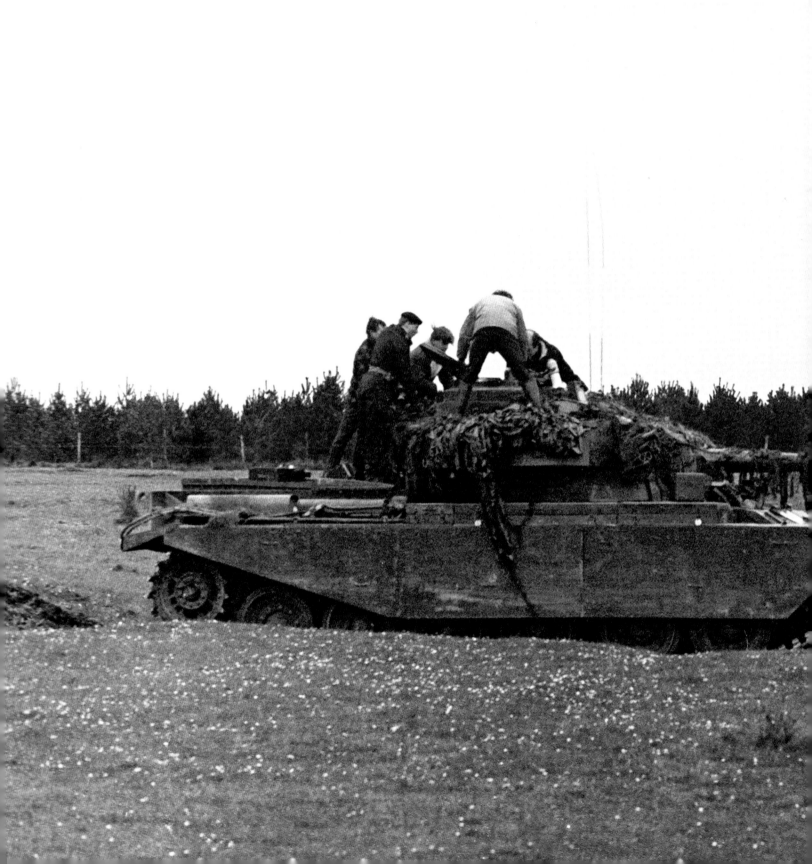

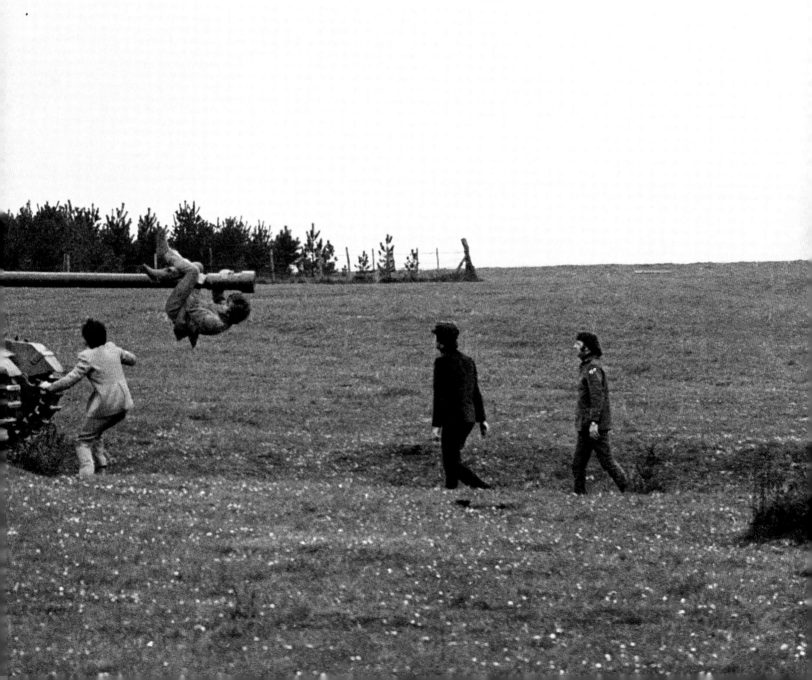

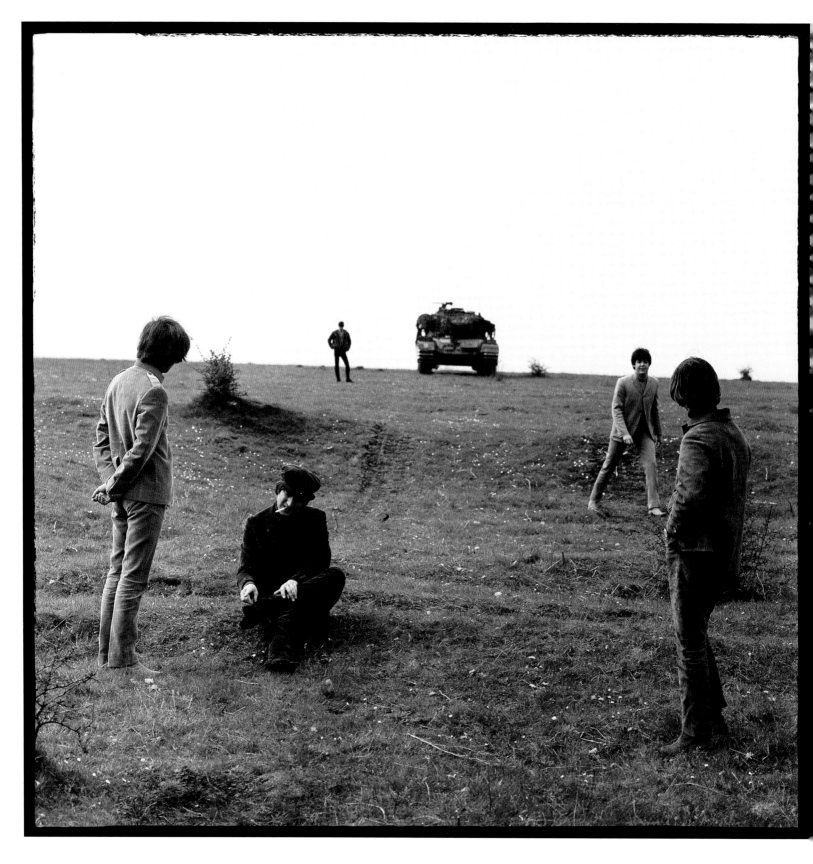

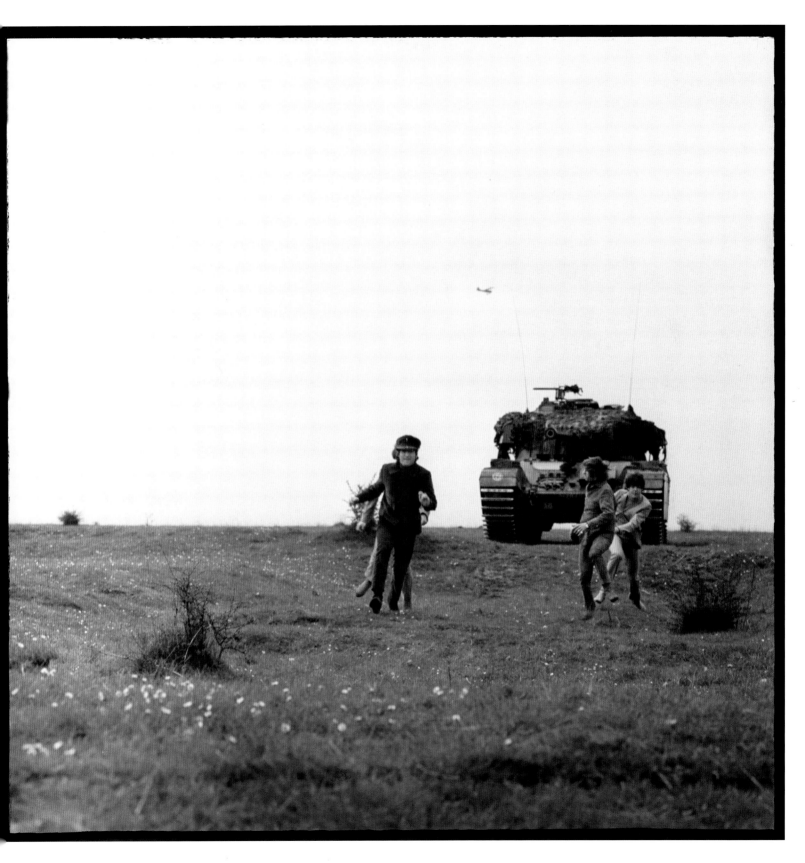

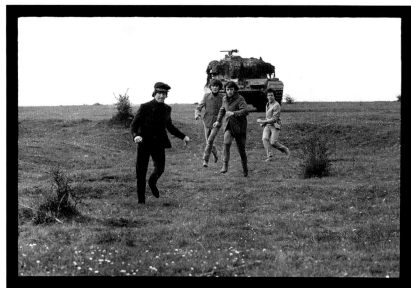
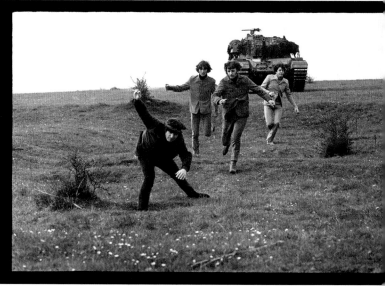
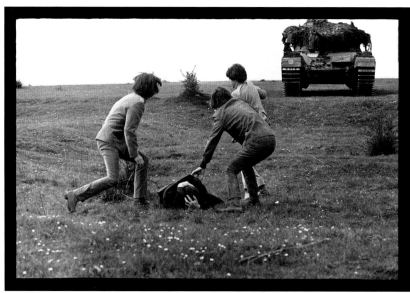
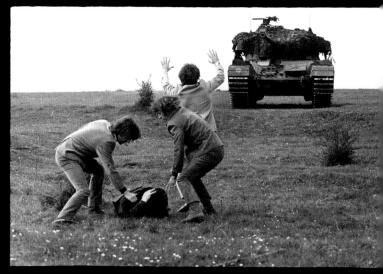

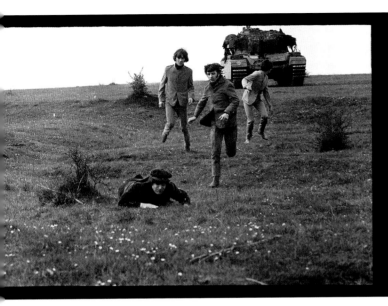
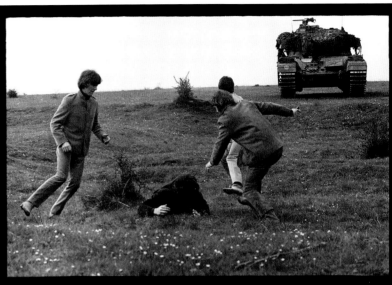
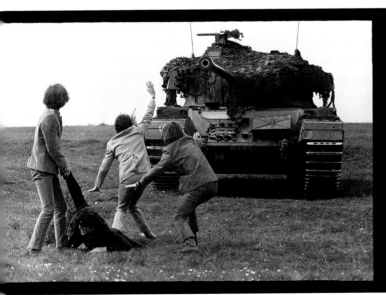
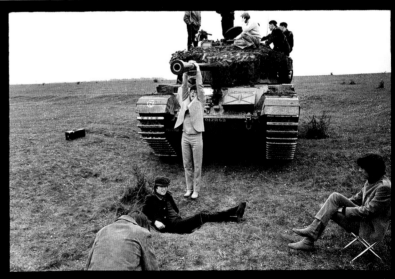

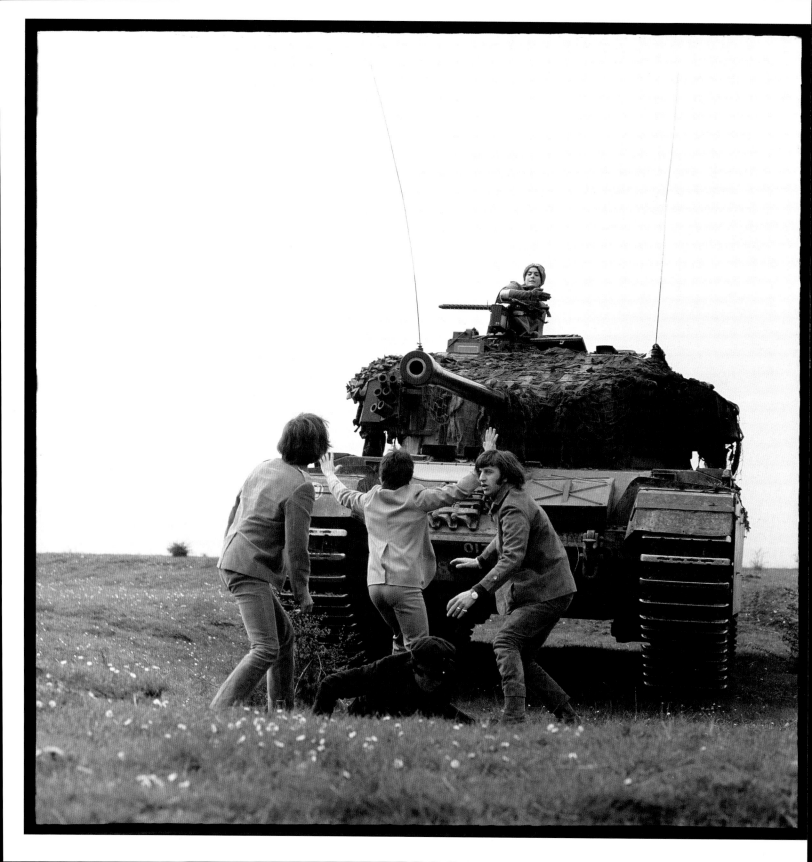

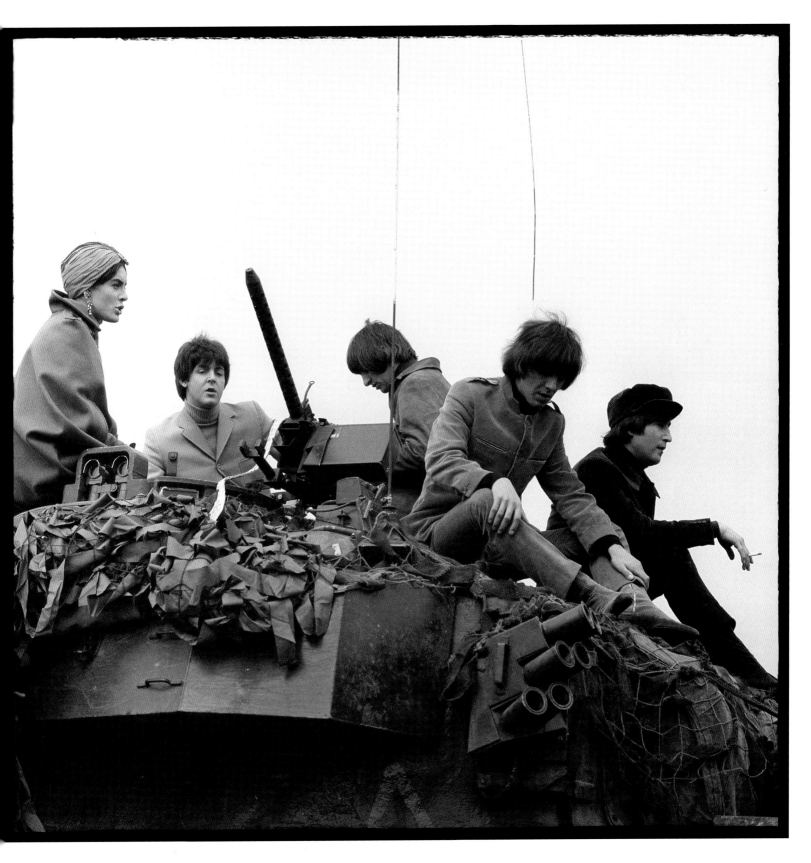

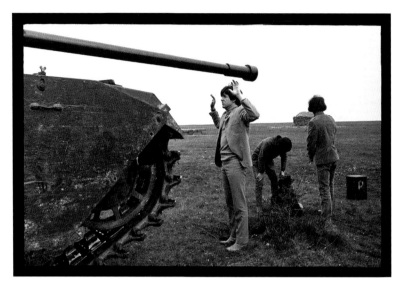

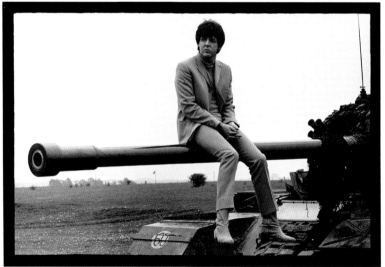

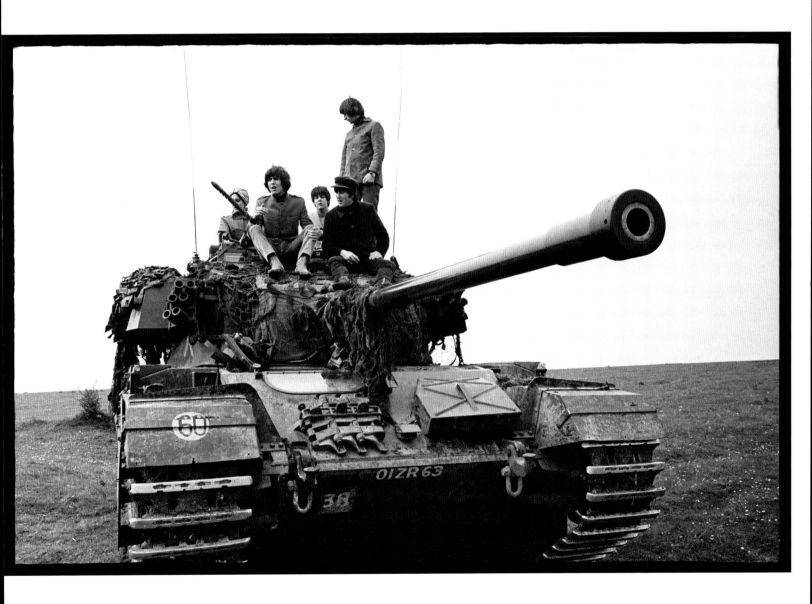

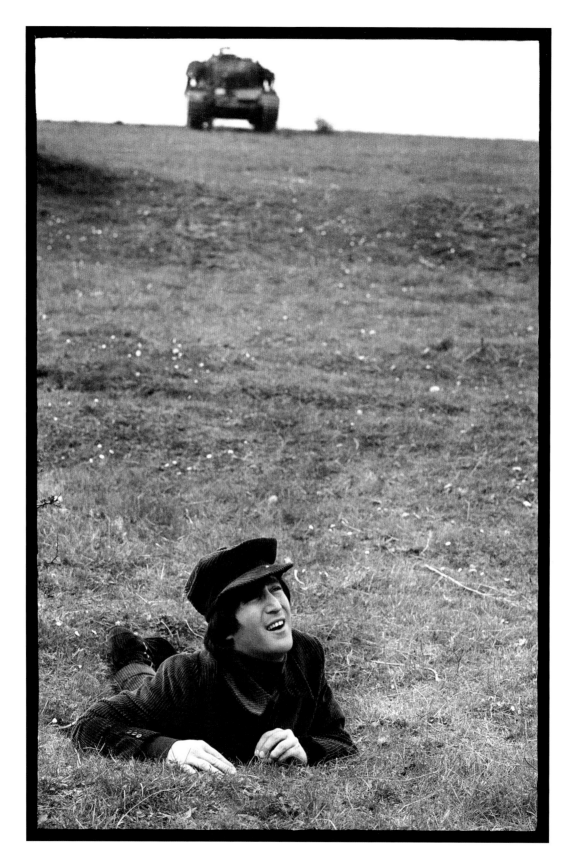

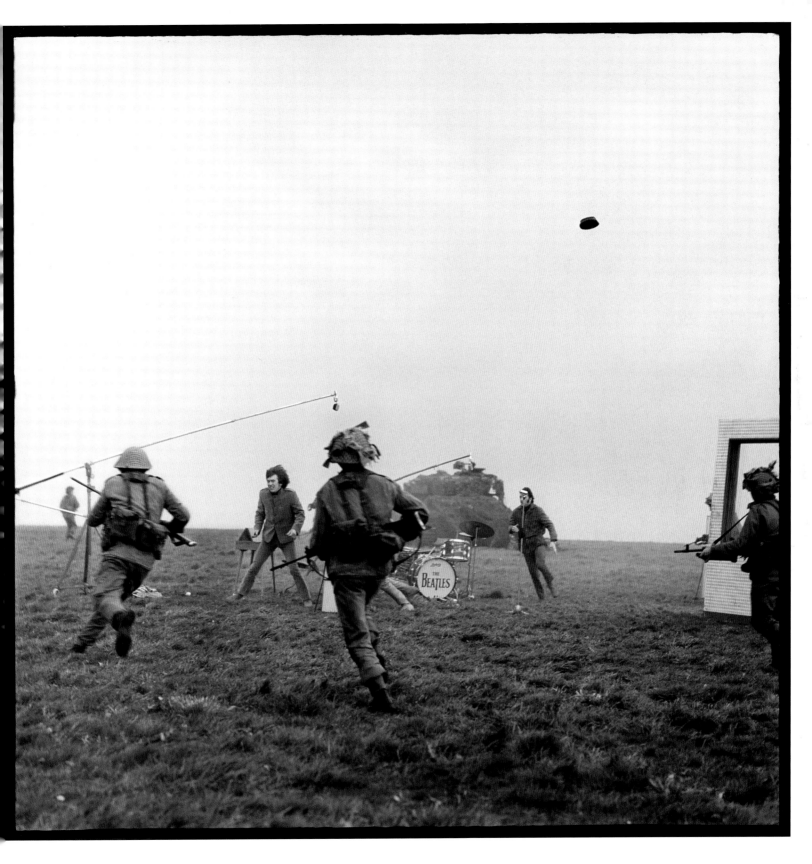

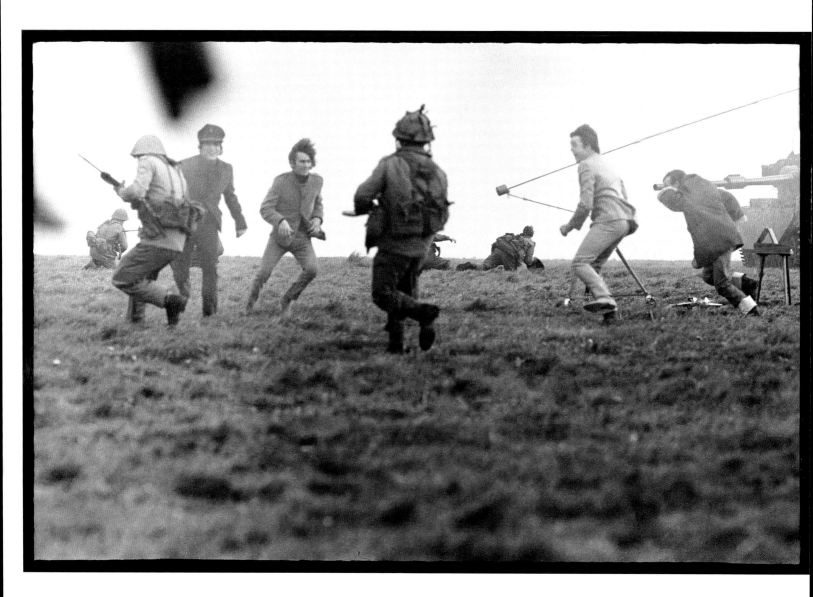

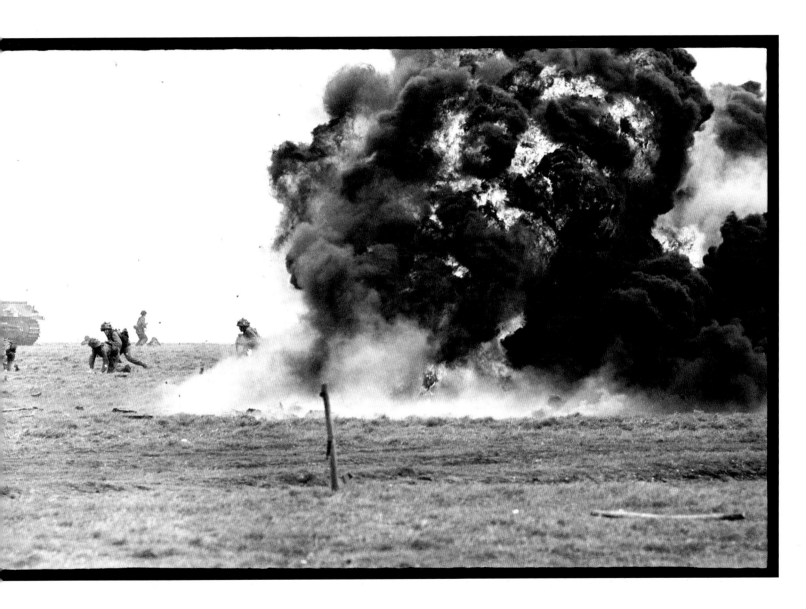

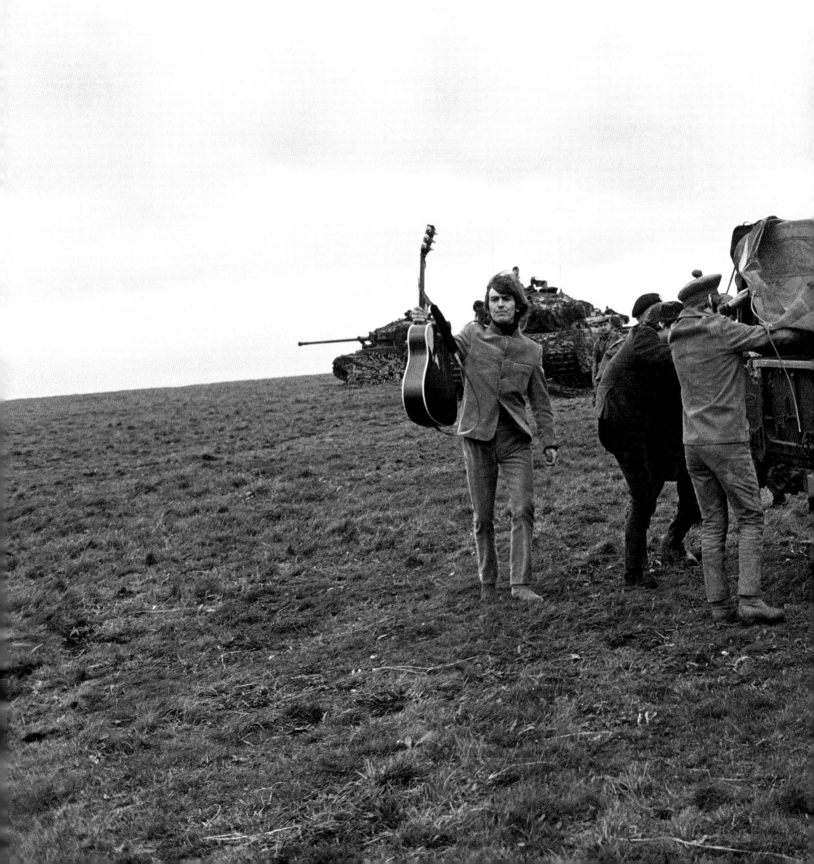

The shooting on Salisbury Plain wrapped on Wednesday, May 5, and the Beatles headed back to London to complete work on a few remaining scenes at Twickenham Film Studios. *Help!* premiered at the London Pavilion on July 29, 1965, and was a box-office smash, further securing the Beatles position as the world's greatest band. It was to be the last dramatic feature they made together.

ACKNOWLEDGMENTS

I would like to thank my nephew Giancarlo Lari for his tireless work in getting this body of work published. I could not have done it without him. I am grateful to Richard Lester for allowing me to shoot on his movie sets in 1964 and 1965 and for the kind introduction that he wrote fifty years later. I also want to thank my wife, Manuela Risi, for her emotional support and my beautiful children, Tommaso and Alexandra. A special acknowledgment goes to Steve Reiss for his vision and encouragement in bringing this project to fruition, and I give thanks to Alastair Gordon and Barbara de Vries for producing, writing, and designing such a beautiful book. Finally I want to thank Charles Miers, Daniel Melamud, Maria Pia Gramaglia, Pam Gonzales, Marny Pereda, and the entire production team at Rizzoli for all their help.

Quotations have been taken from the following source material:

Author interview with Emilio Lari, February 11, 2015.
The Beatles Anthology (London: Cassell & Co., 2000).
The Beatles in Help!, a thirty-minute documentary about the making of *Help!* that includes an interview with Richard Lester (Capitol Records / Apple Corps Ltd., 2007).
The Beatles in Help!, a novelization by Al Hine (New York: Dell Publishing, 1965).

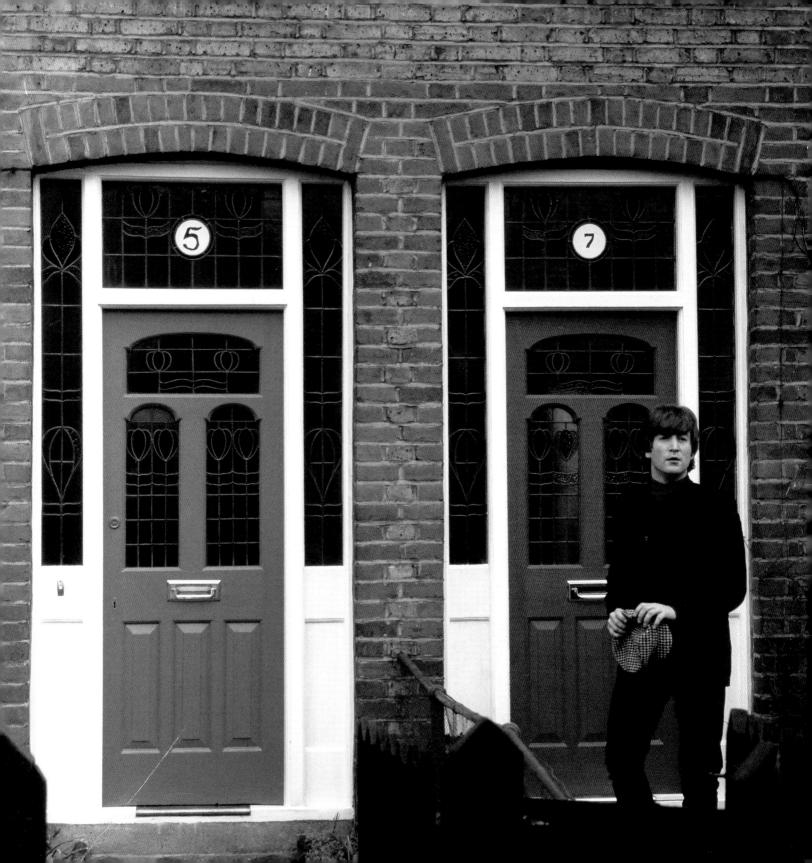

First published in the United States of America in 2015 by
Rizzoli International Publications, Inc.
300 Park Avenue South
New York, NY 10010
www.rizzoliusa.com

in association with

Gordon de Vries Studio
www.gordondevriesstudio.com

Photographs © Emilio Lari
Introduction © 2015 Richard Lester
Text © 2015 Alastair Gordon

Design: Barbara de Vries

Publisher: Charles Miers
Editor: Daniel Melamud
Production: Maria Pia Gramaglia

Library of Congress Control Number: 2015936934
ISBN: 978-0-7893-2946-2

2015 2016 2017 2018 / 10 9 8 7 6 5 4 3 2 1
Printed in China

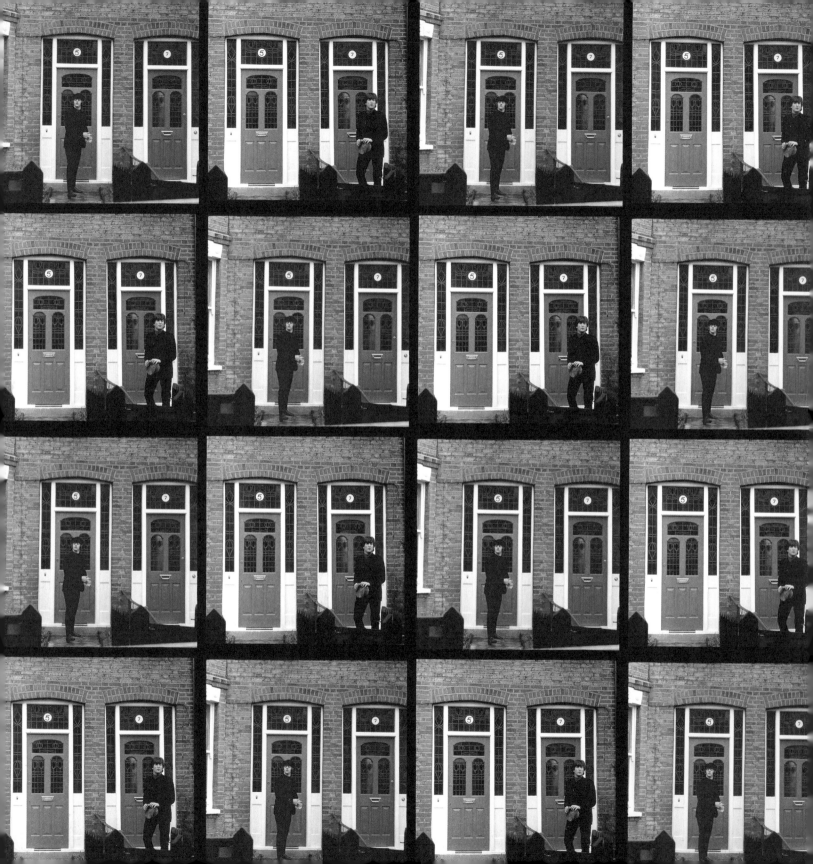